PICTURE TAKER

PICTURE TAKER

Photographs by KEN ELKINS

Foreword by RICK BRAGG

The University of Alabama Press • Tuscaloosa

Publication of this book was made possible in part through the
generous support of the *Anniston Star*

Typeface: Minion

∞

The paper on which this book is printed meets the minimum requirements of American
National Standard for Information Science—Permanence of Paper for Printed Library
Materials, ANSI Z39.48-1984.

Library of Congress Cataloging-in-Publication Data

Elkins, Ken.
 Picture taker: the photographs of Ken Elkins / Kenneth Elkins; With foreword by
Rick Bragg.
 p. cm.
 ISBN 0-8173-1478-4 (cloth : alk. paper)
 1. Photojournalism—Alabama. 2. Country life—Alabama—Pictorial works.
3. Elkins, Ken. I. Title.
 TR820.E48 2005
 779'.99761—dc22 2004025921

For Marcie,

And for Karen, Keith, Ansel, and Hilary

CONTENTS

Foreword
Ken Elkins: The Picture Taker ix
 RICK BRAGG

The Photographs 1–100

Afterword
Ken Elkins: A Career in Pictures 101
 BASIL PENNY

Captions 105

FOREWORD

Ken Elkins: The Picture Taker

Rick Bragg

Rural Northeastern Alabama is one of the greenest places on earth. The towns are mostly small, with names like Lineville, Ashland, Piedmont, Fruithurst, places not big enough to scar the mountains and valleys very much, not busy enough to disrupt the life that, even now, moves at a pace a body can stand. You catch a breath in the city. Here, you breathe.

The people do not like to be pushed or hurried. They do not care how you do it up north. The very old still care more about how to make a good whisk out of broom sage than whether or not they get a Wal-Mart.

But it would be a lie to say that life here proceeds as it always has. The old ways are gone, or going, and the scenery is different. You do not see as many old women snapping beans on unpainted porches, do not smell cracklin's on the autumn breeze, do not see a mule dragging a plow across the red dirt, an old man in overalls hunched over the reigns.

The old scenes are gone, or going. Some of us will try to remember them, but it gets harder and harder, fainter and fainter. We vaguely recall a 1953 Chevrolet half covered in kudzu, but for the life of us we can't take you to it.

And the people are different, less likely to be in overalls and print dresses, less likely to cut a sliver of tobacco off a sweet-smelling plug of Brown Mule, or take a little dip of snuff. The barns are mostly gone, the mules just dust and bones, the bountiful and elegant gardens slowly being reclaimed by weeds.

So we try to remember, imperfectly.

But not Ken Elkins.

Elkins froze his memories in black and white, sighting gently on these people and places through his viewfinder and later burning them onto paper in his darkroom, saving them from time itself.

He has been called a consummate photographer, a gifted artist, and his works have hung in galleries. He has been toasted and honored and he has won more awards than he can recall.

All of which, in Millerville or Rabbittown, will get you doodly squat.

Ask the people here, in this deep green, if they know Ken Elkins, the award-winning photographer, and they will only smile.

"You mean," they will say, "the picture taker."

People here love Elkins like family, because he and his camera have found value in their lives that so many others—a world full—were unable to see.

I have worked with some of the finest photographers on this planet, brave men and women who kept their cool as militant Islamic fundamentalists screamed hatred at them, who did their duty as Haitian strong men fired rifles into milling, terrified crowds. I have seen men and women turn those images into pure art, with photographs that break your heart and lift your spirit and make you see life more clearly, somehow, than you saw it even when you were standing right there, living it. I have worked beside the very, very best.

But I only know one picture taker.

He dreamed he met Jesus in a green meadow off Highway 49 in Clay County, in a place the people call Shinbone Valley. Jim Yardley, then a writer for the *Atlanta Journal-Constitution*, wrote of Elkins that it was appropriate, somehow, that Elkins met Him there, in the lonely but beautiful landscape. It has always been his church.

Over four decades as chief photographer for the acclaimed small newspaper, the *Anniston Star*, Elkins did his duty at governor's races and stock car races, at high school football games and bowl games, at Klan rallies and Easter egg hunts and tent revivals.

But when he turns his lens on the mostly rural, mostly poor pockets of his native Alabama, something beautiful happens. He draws out the dignity and loveliness that is in these people, and spreads it out for the rest of the world to see.

It is hard not to love a man who gave his life to that.

I don't know much about Elkins the man, just the photographer. I have always been reluctant to get to know the men behind great talent—I had always been reluctant to seek out Willie Morris, or Pat Conroy, Larry McMurtry, others—because I was afraid what I would find would somehow tarnish the work.

What I know about him is that he looks a lot like Mark Twain, that he quietly loves the Lord, that he has owned more than one car that he had to start with a screwdriver, that his heart is so tender that he hates to hook a fish too deep because it might kill it, that there is no assignment so pressing that one cannot stop off for some sharp cheddar and crackers. He also paints a bit.

But the work I know.

He has been compared to Walker Evans, whose 1941 book with James Agee, *Let Us Now Praise Famous Men*, documented sharecropper poverty in Alabama. But there is a profound difference.

The best I have ever heard it described was by Yardley, now with the *New York Times*, who wrote in a 1991 feature on Elkins:

> Mr. Evans presented a damning, depressing portrait of rural poverty. Mr. Elkins, who was born up the road in Marshall County, has a different focus. He rejects the stereotypes of despair and ignorance often depicted by big city photographers on safari, and reveals his subjects as individuals who have endured hard lives but have found humor, dignity and faith. People often smile in Mr. Elkins's portraits.

I know I look at them and I am home.

I look at the black and white of a revival, at an old man in overalls kneeling as the hand of the evangelist rests on his head, as an old woman sobs in the background, her hands clasped, and I no longer question the power of faith.

I look at an old man sitting with his shotgun in a cornfield, waiting on the crows, and I understand the real meaning of time.

I see a gang of urchins walking a railroad track barefoot, and I remember how to be a boy.

I see an old man in crooked suspenders shuffle hump-backed through a gate, tools in his hand, and I know what I want to do and be when my time is almost over.

And I see a railroad track in the mist, one of those tracks that offers a way out of this, an escape from this isolation and poverty and inertia, and I know why so many people never leave.

Because Elkins shows the reasons to stay.

PICTURE TAKER

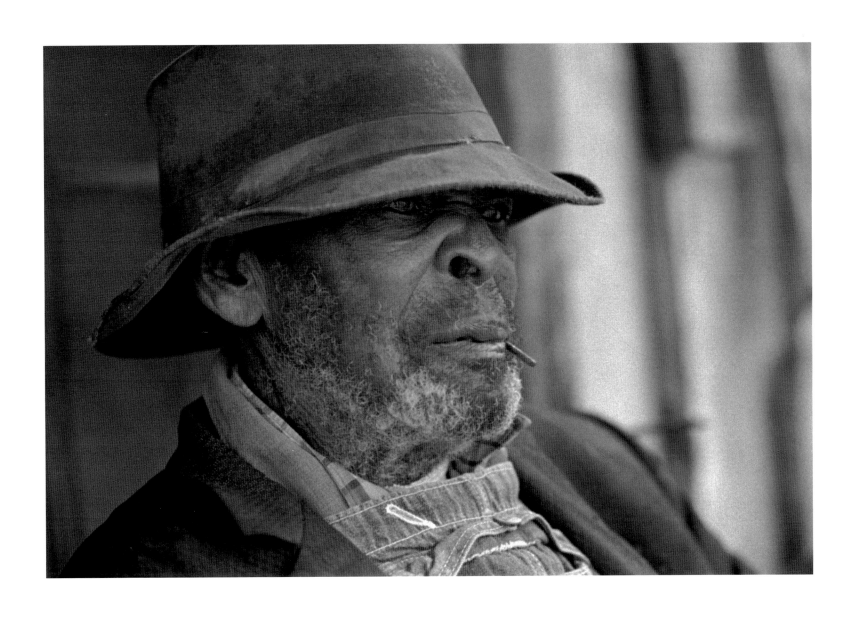

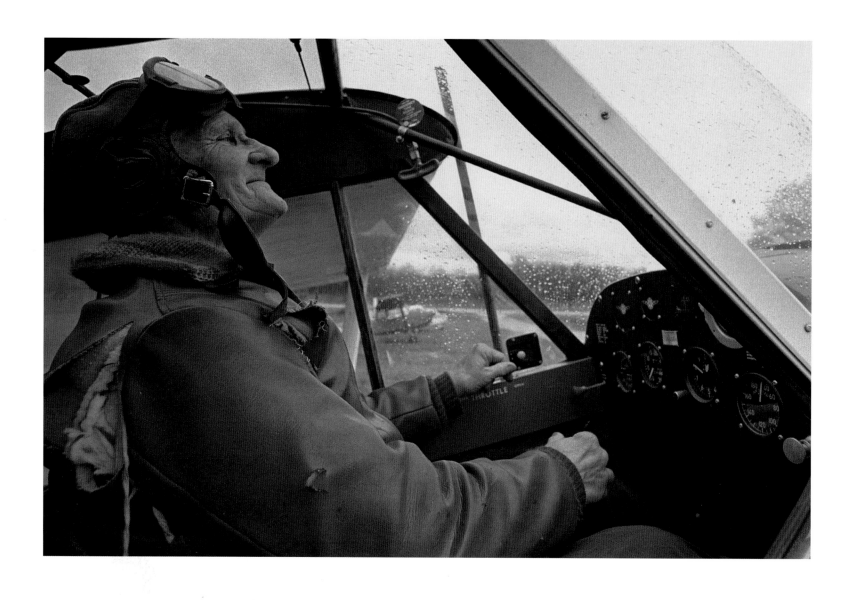

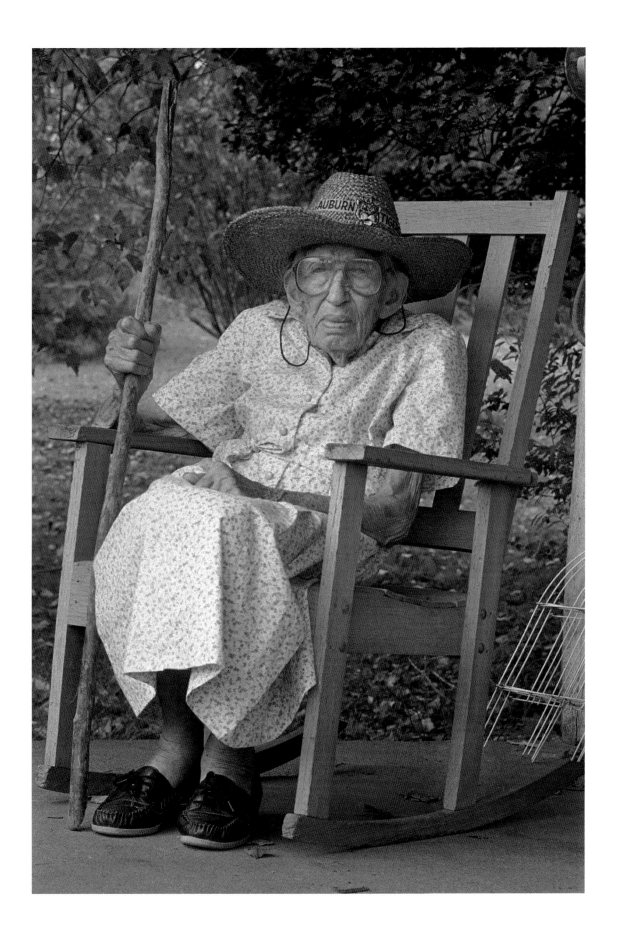

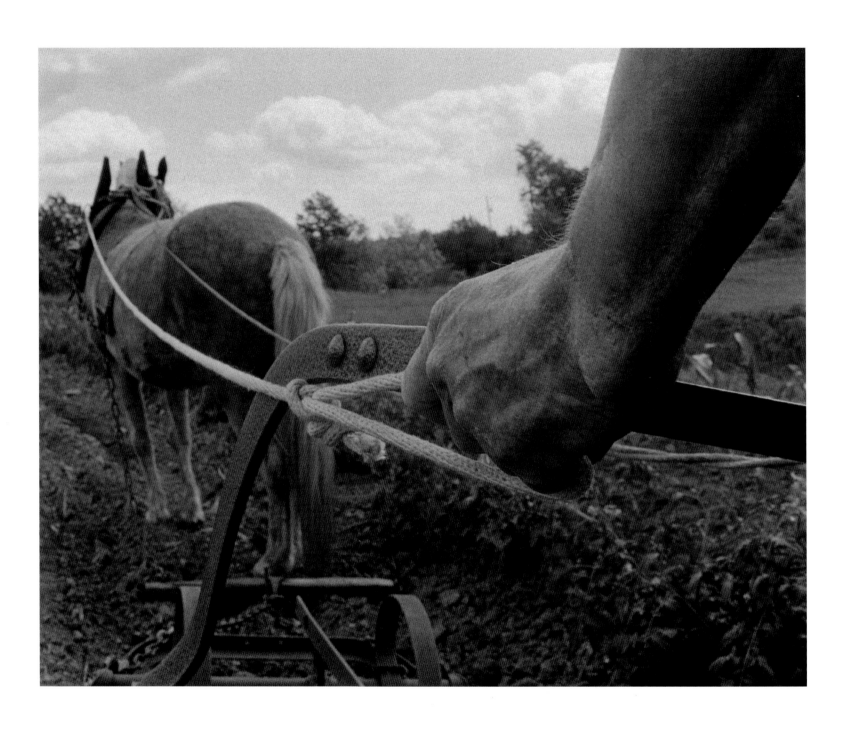

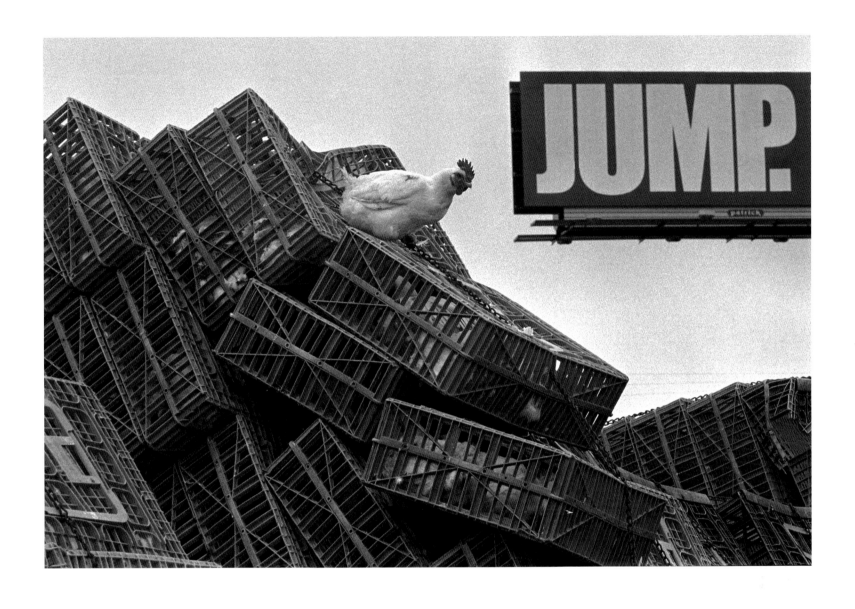

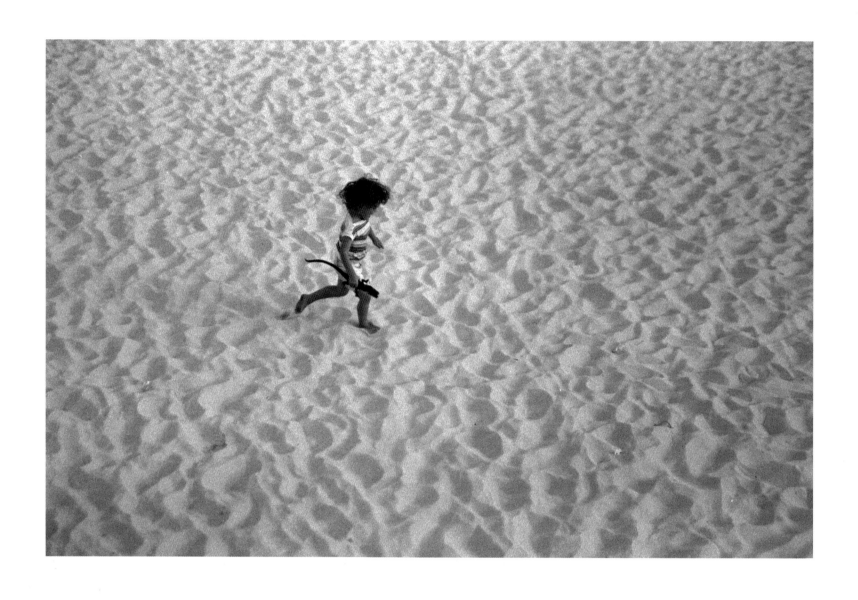

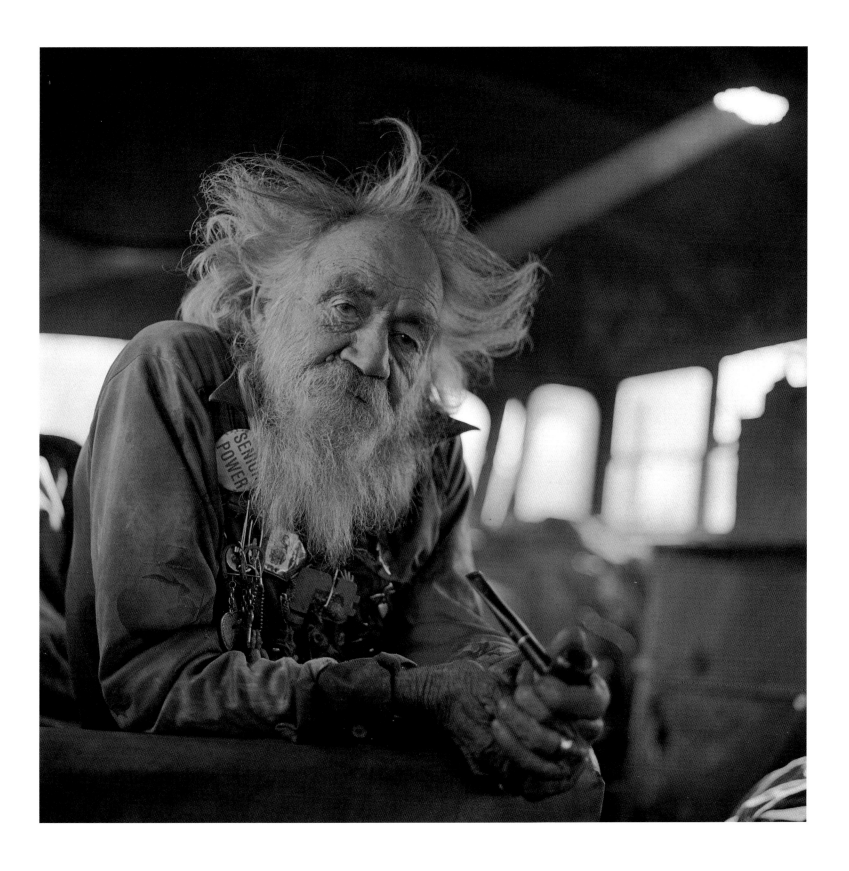

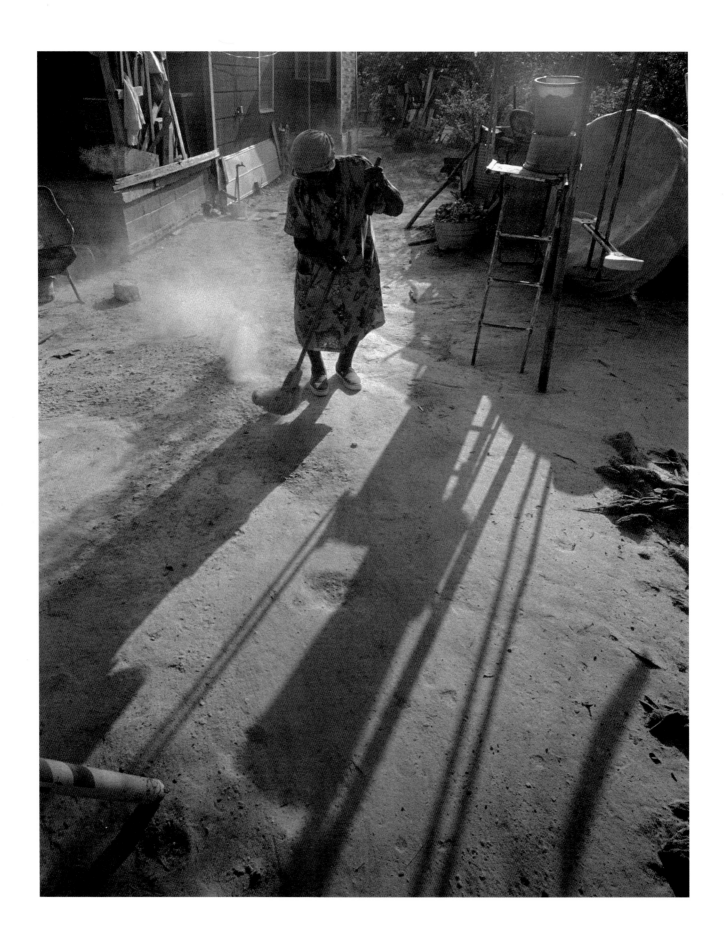

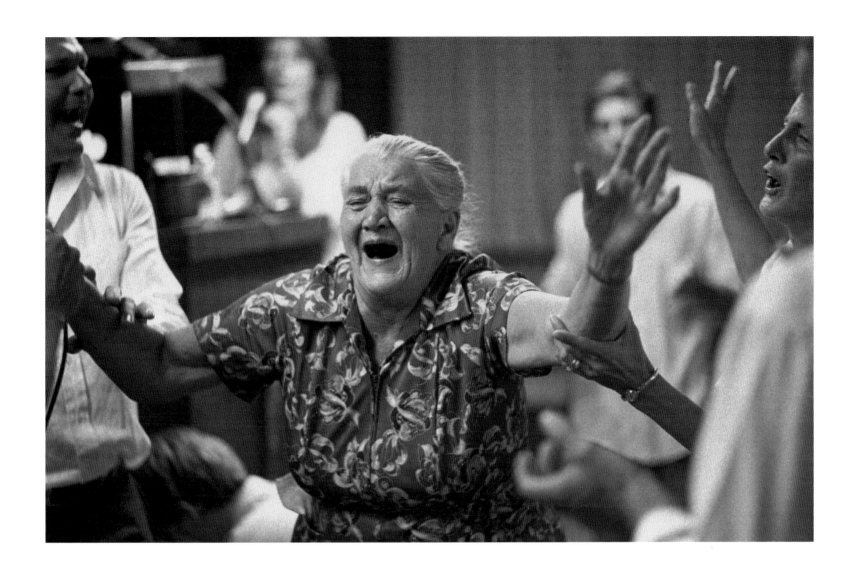

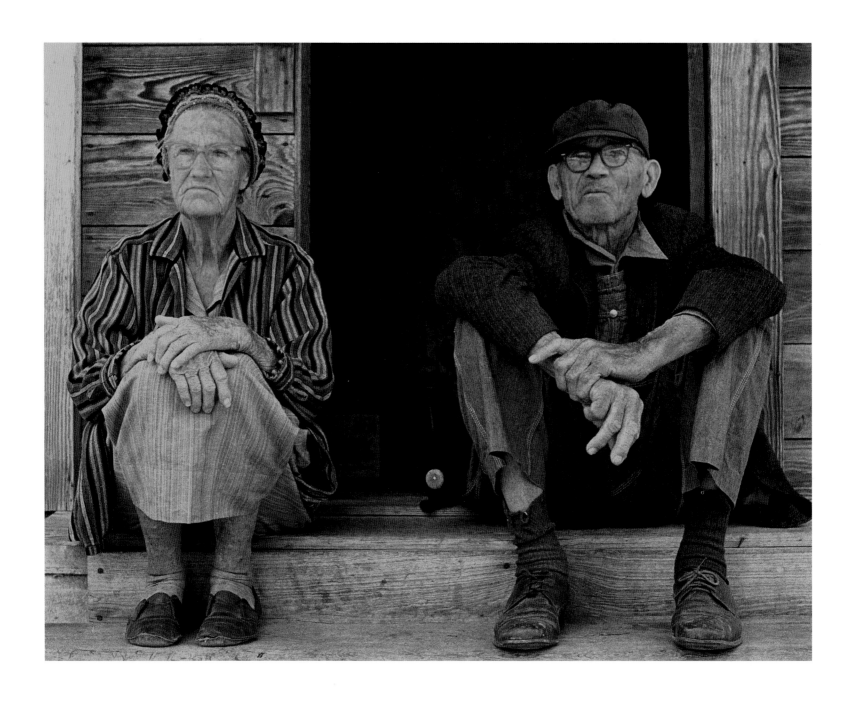

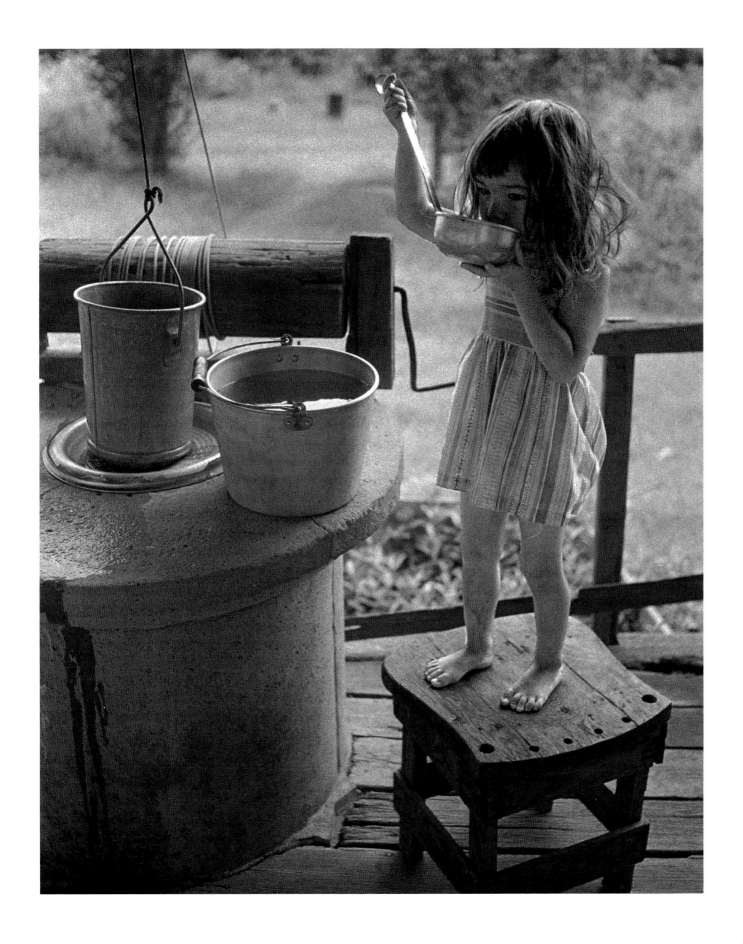

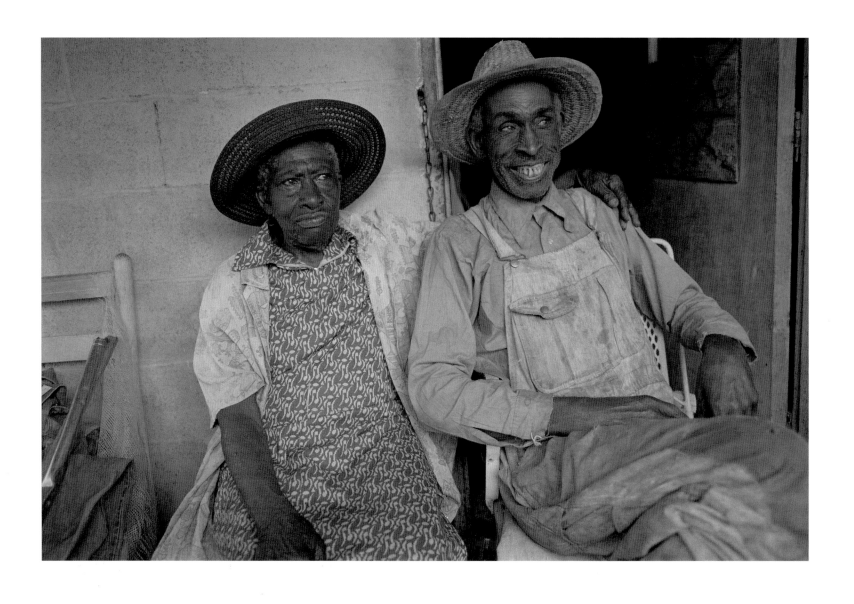

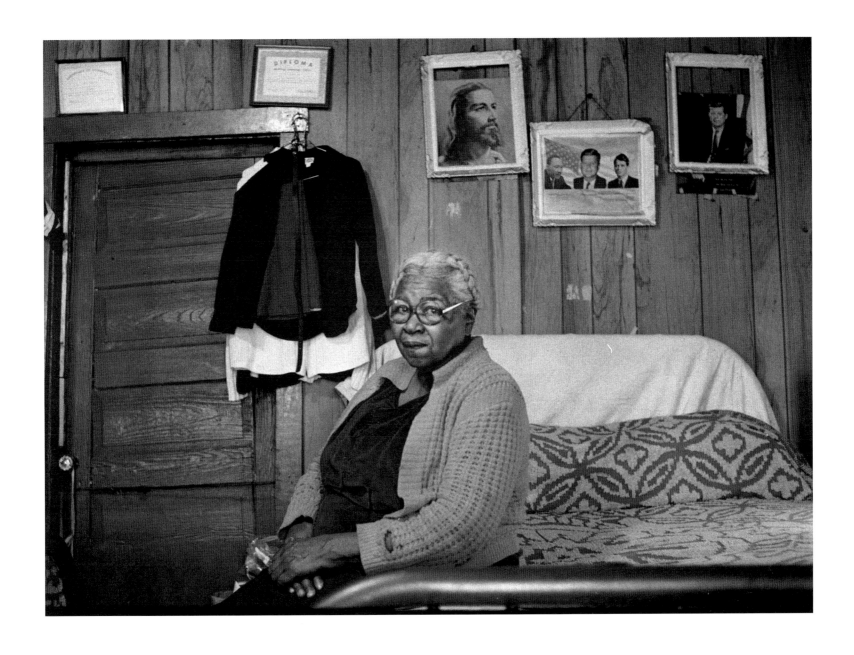

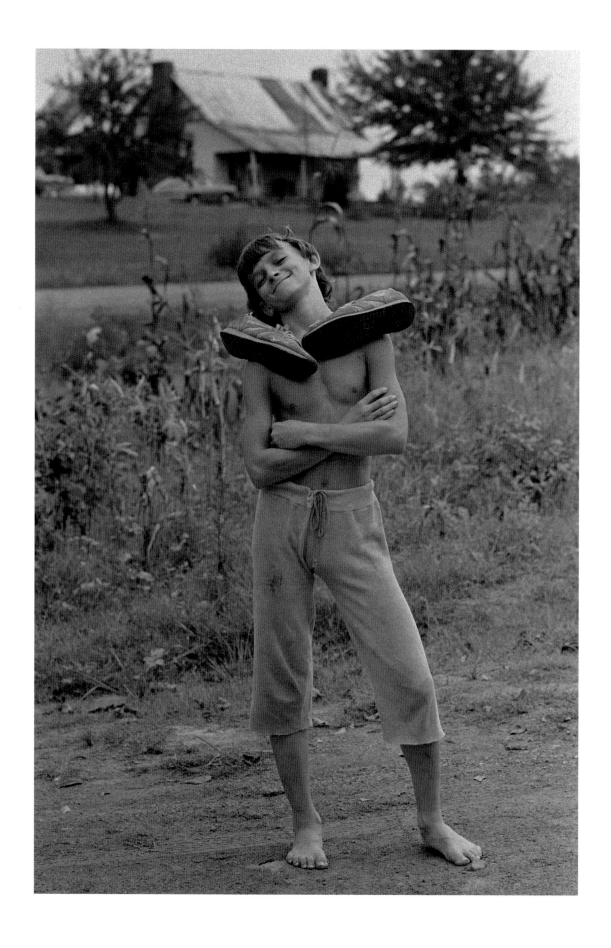

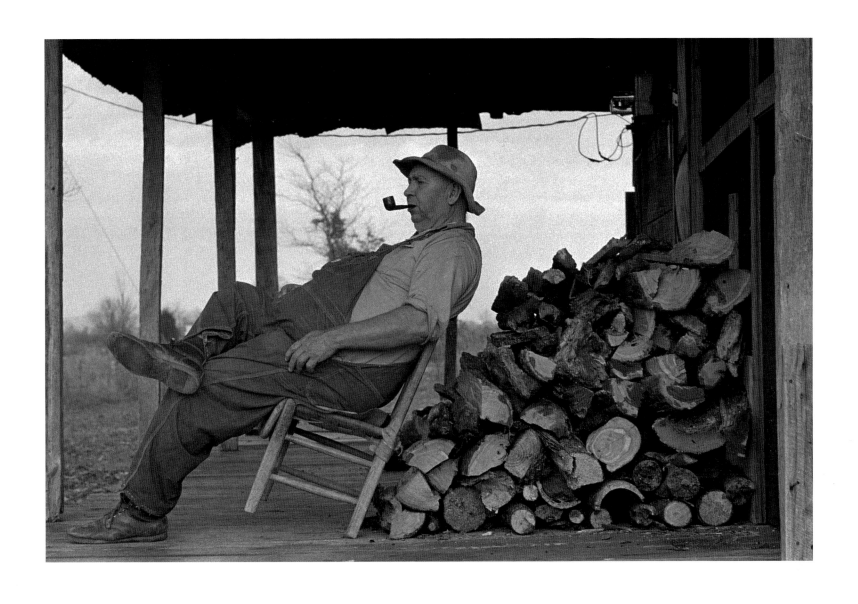

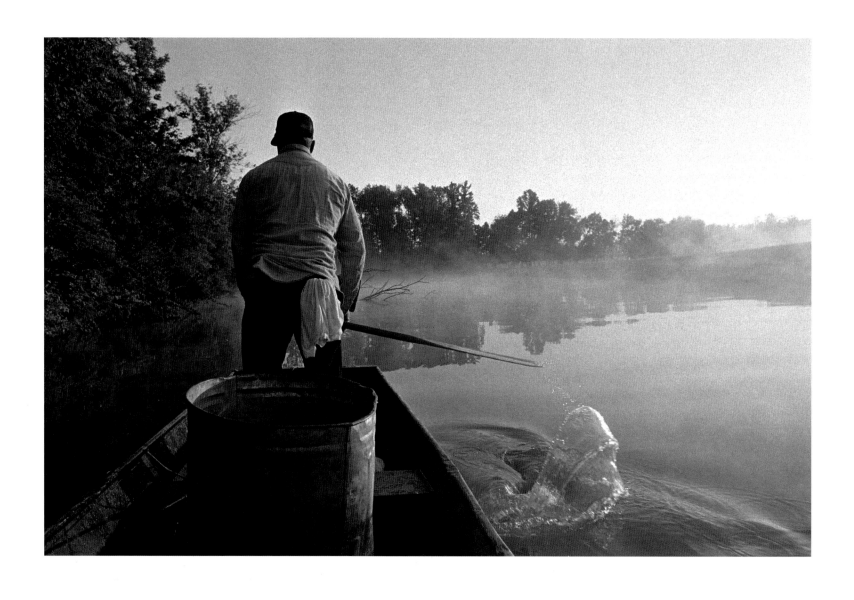

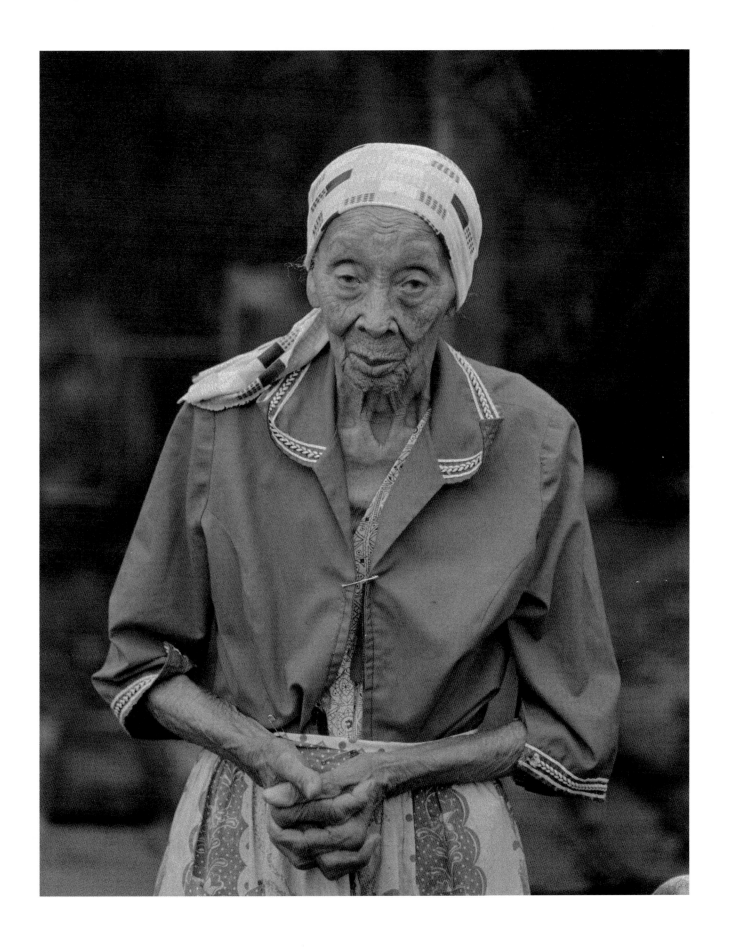

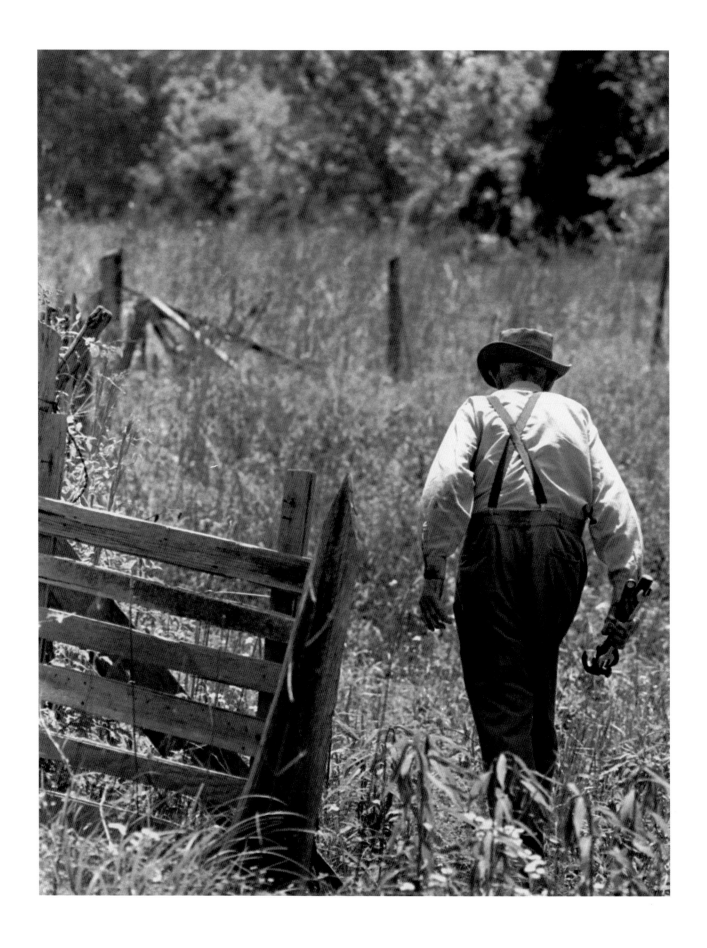

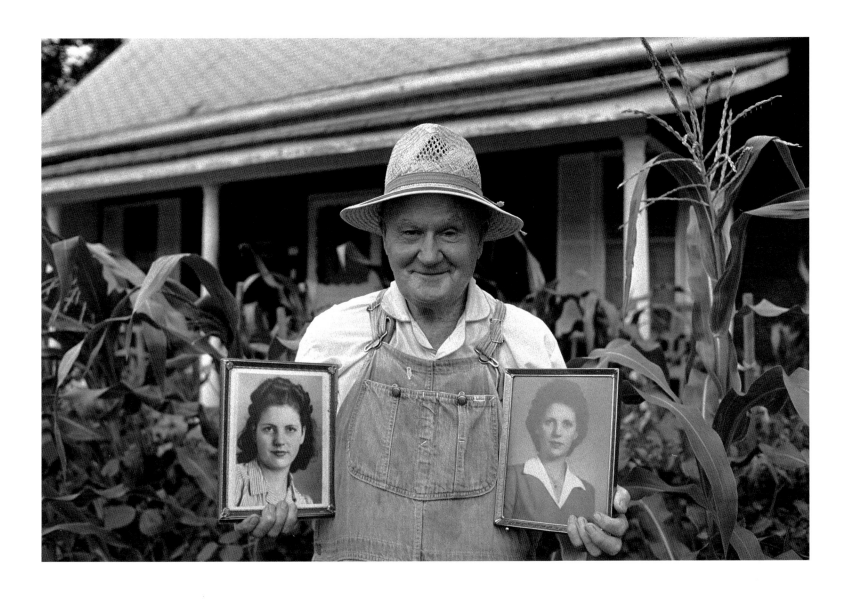

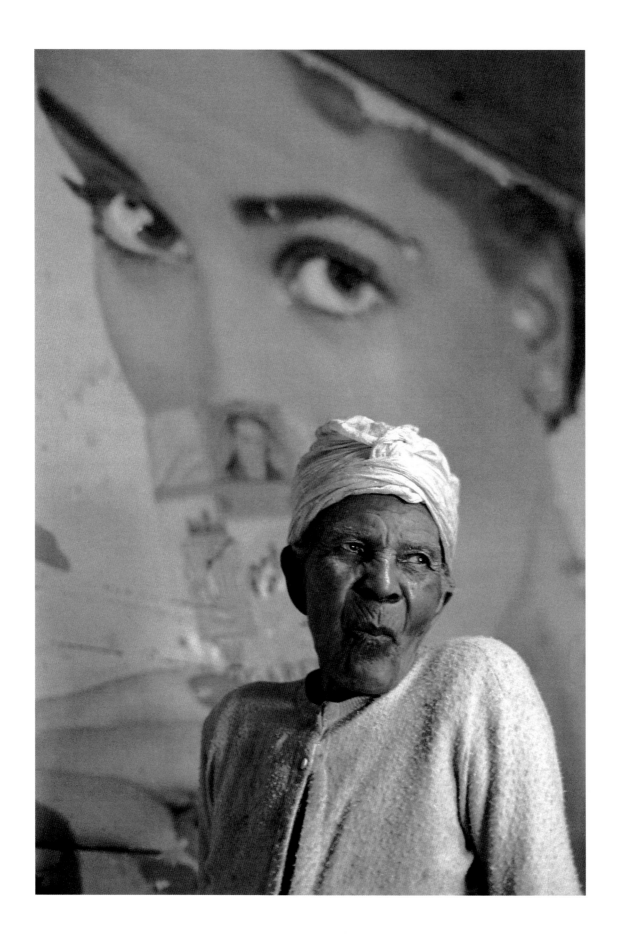

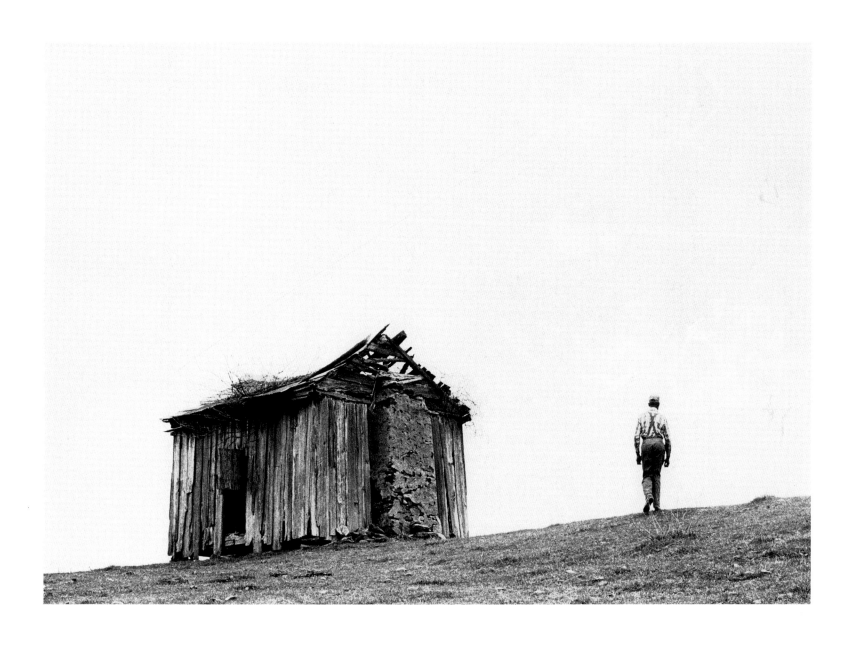

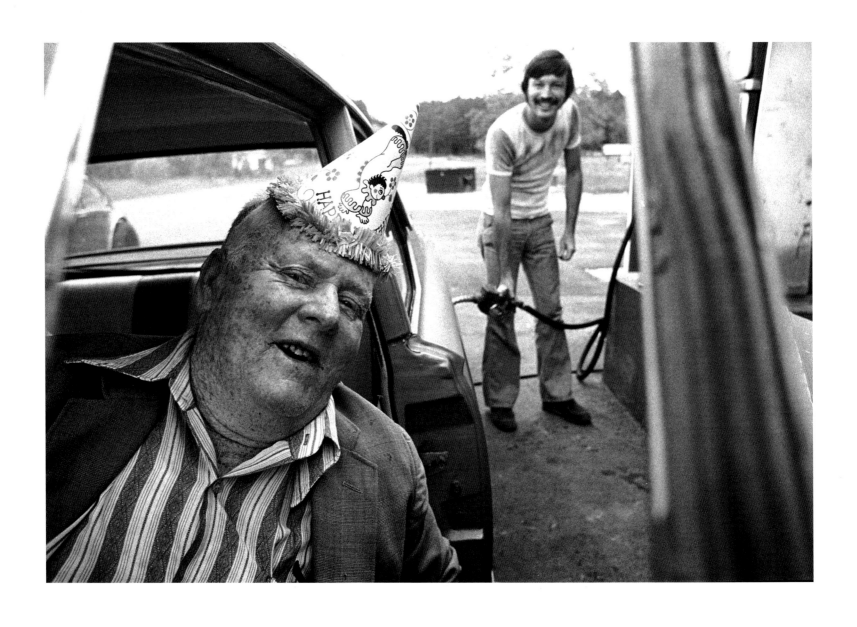

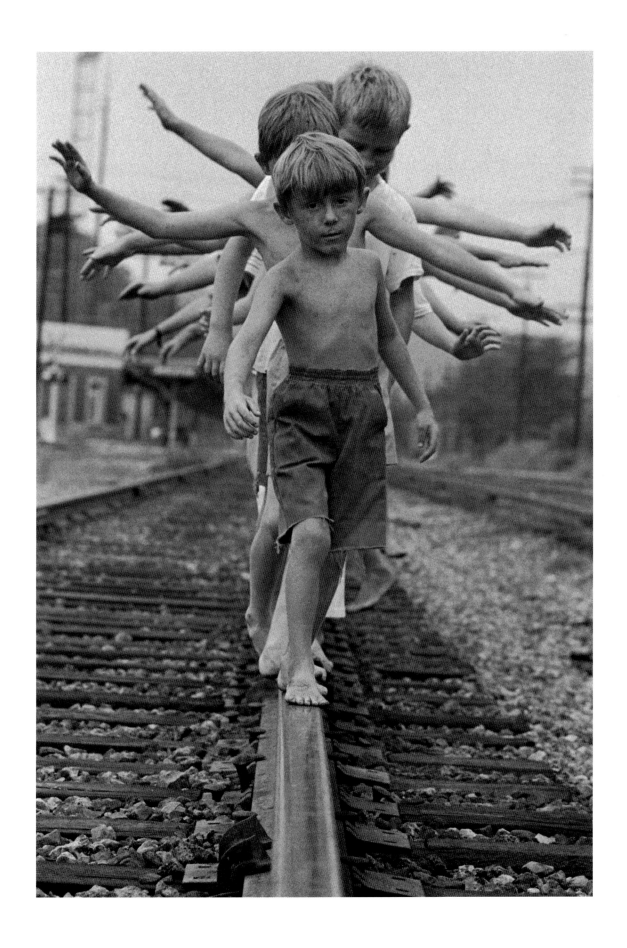

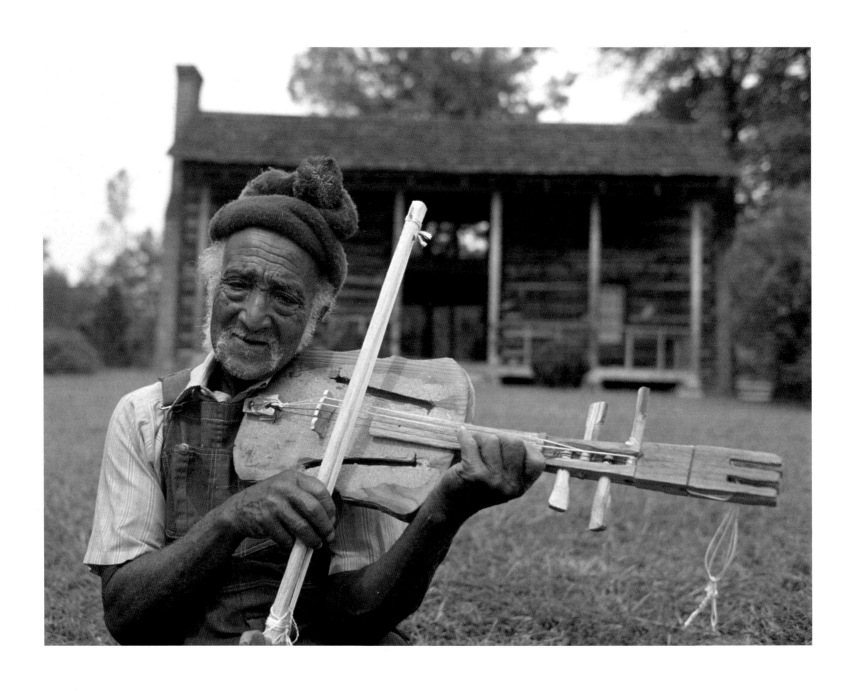

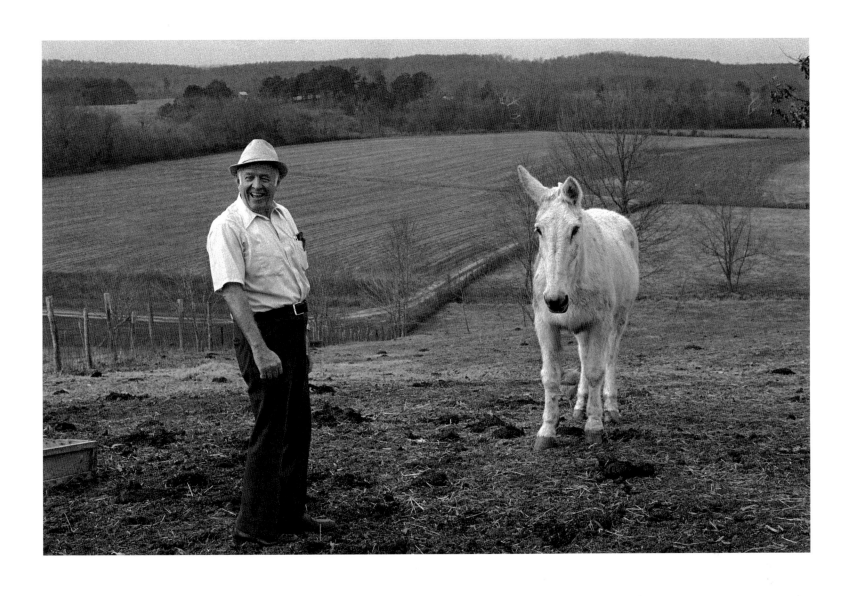

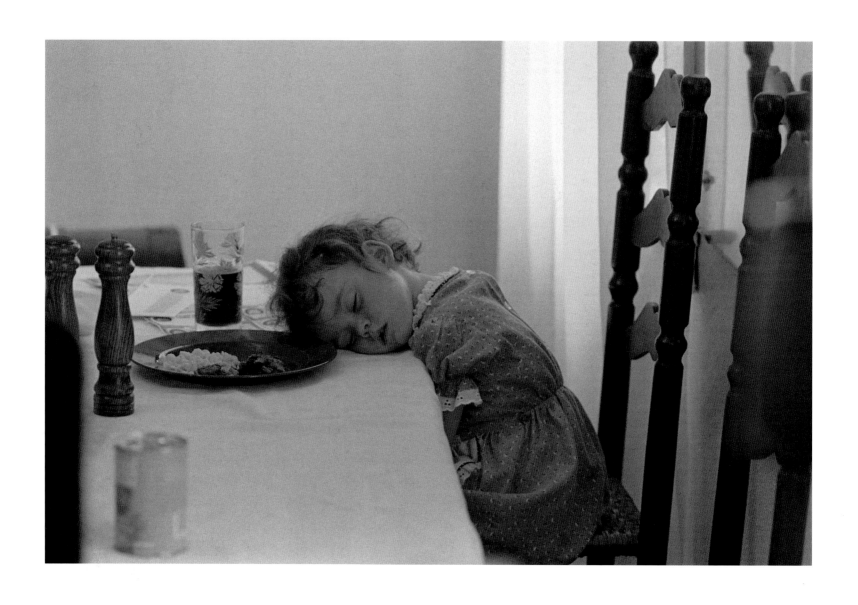

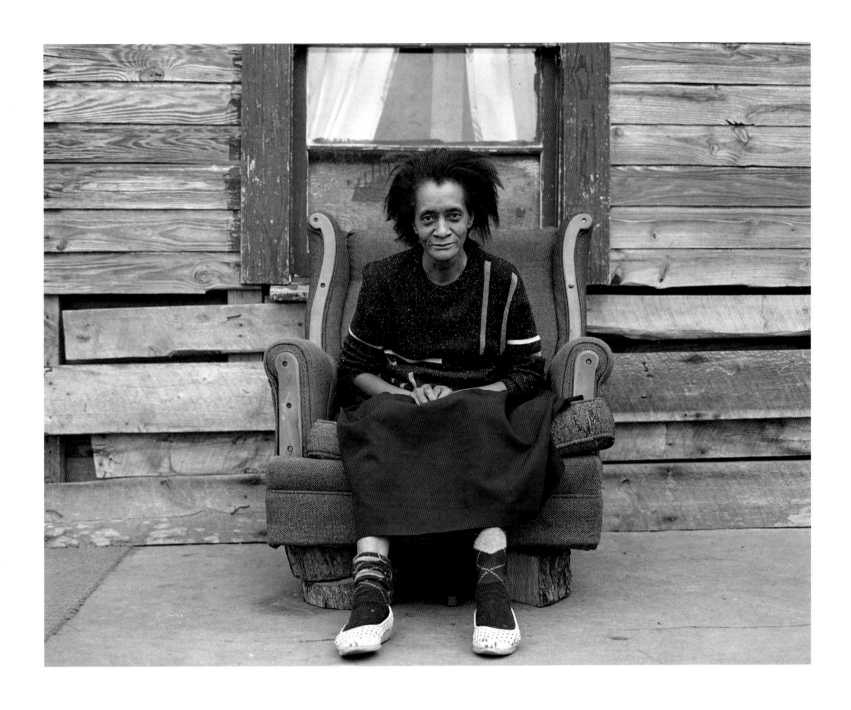

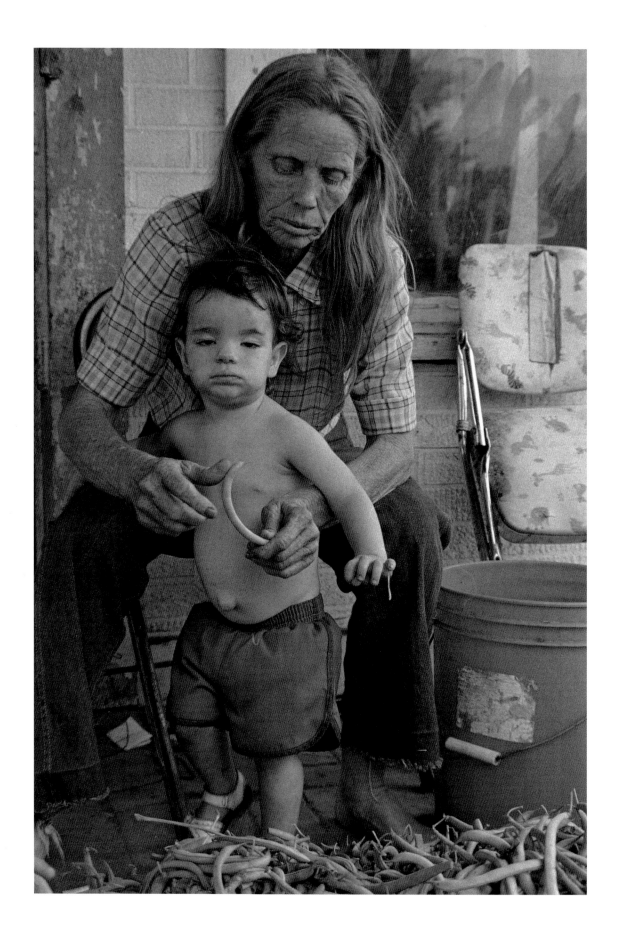

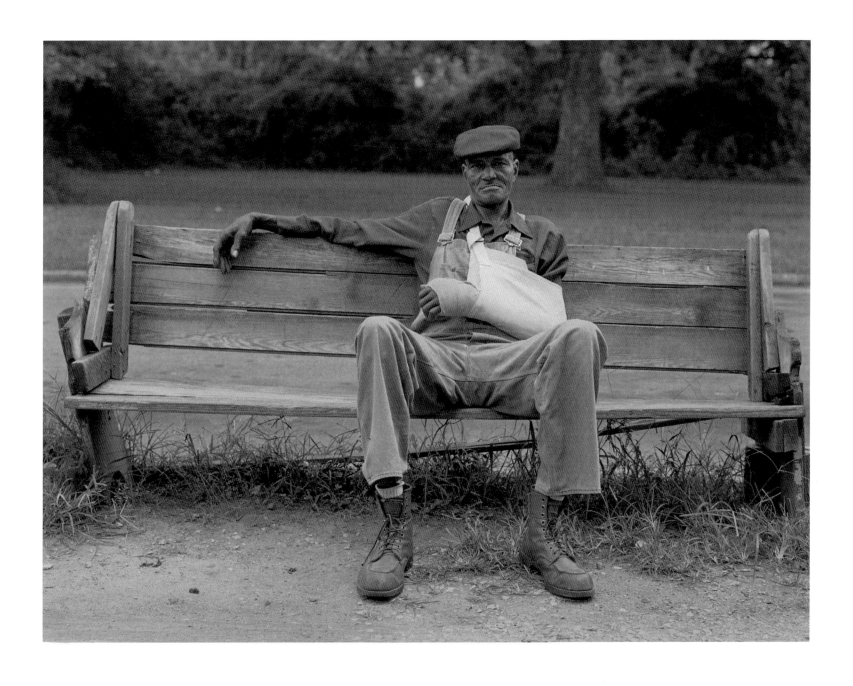

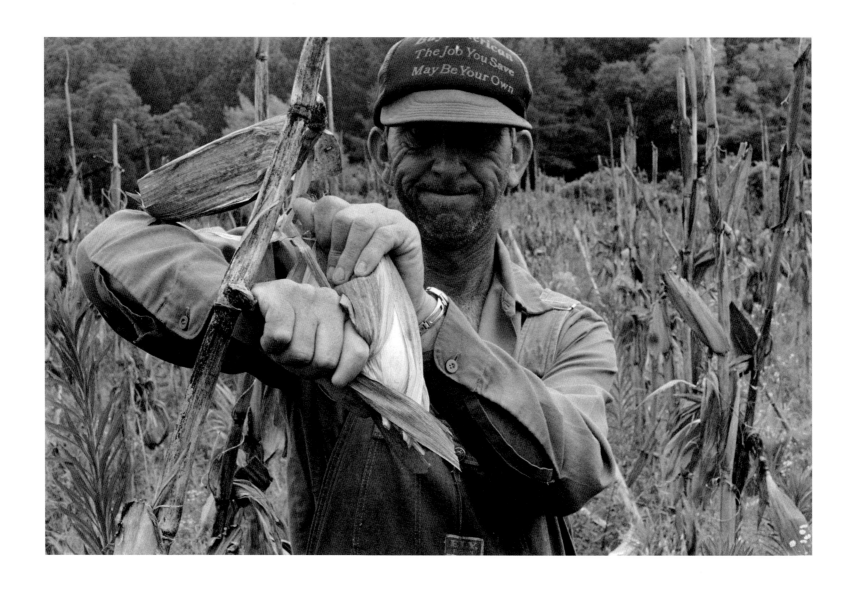

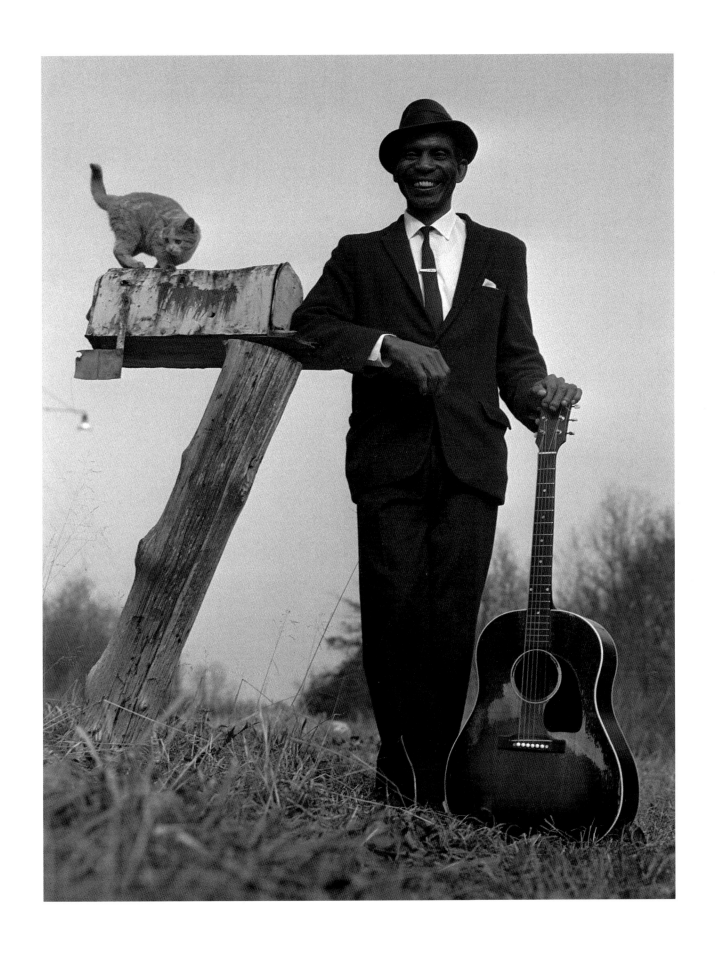

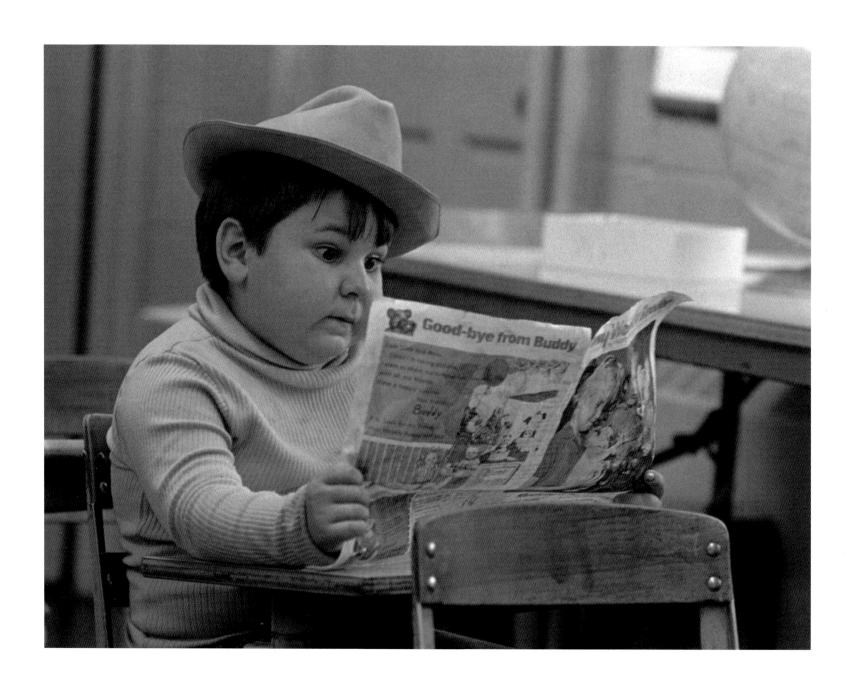

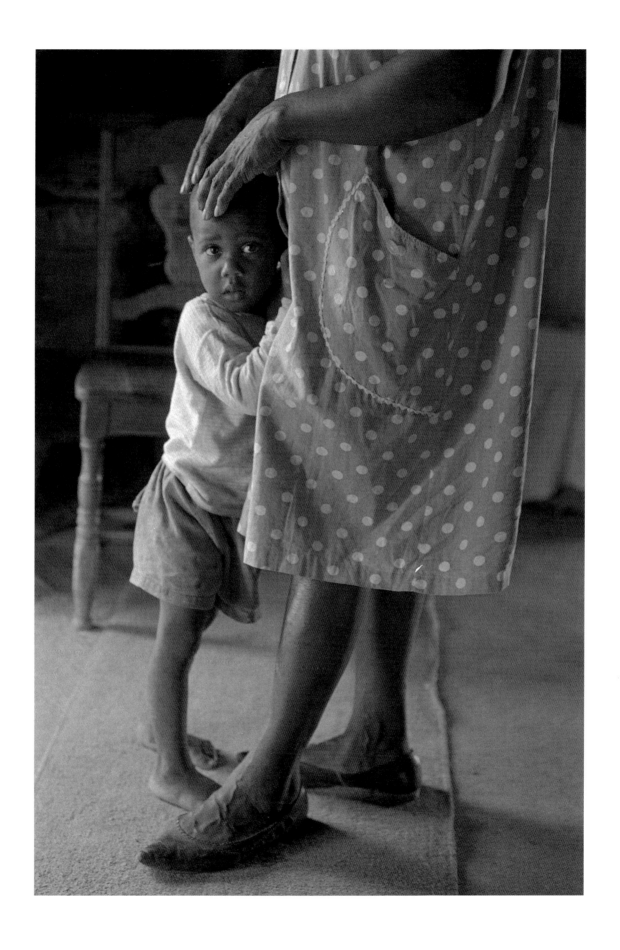

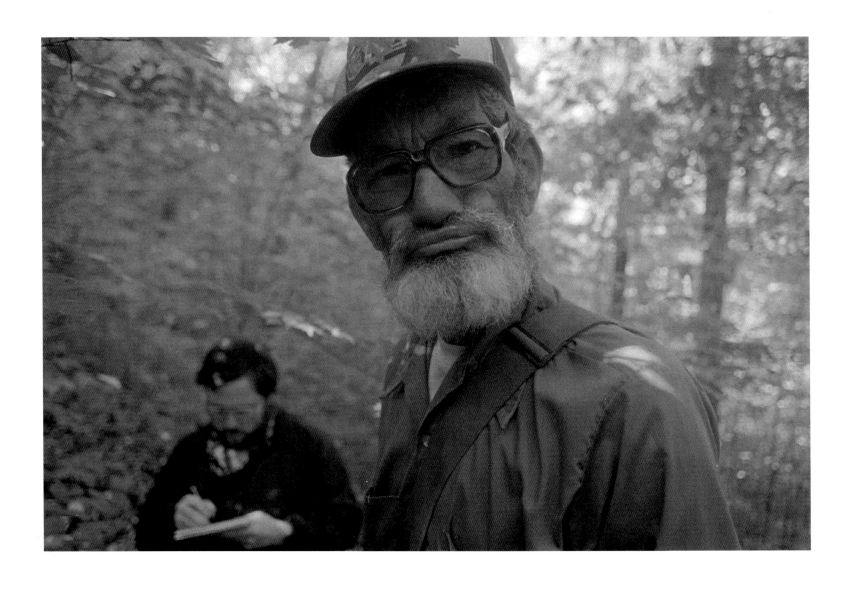

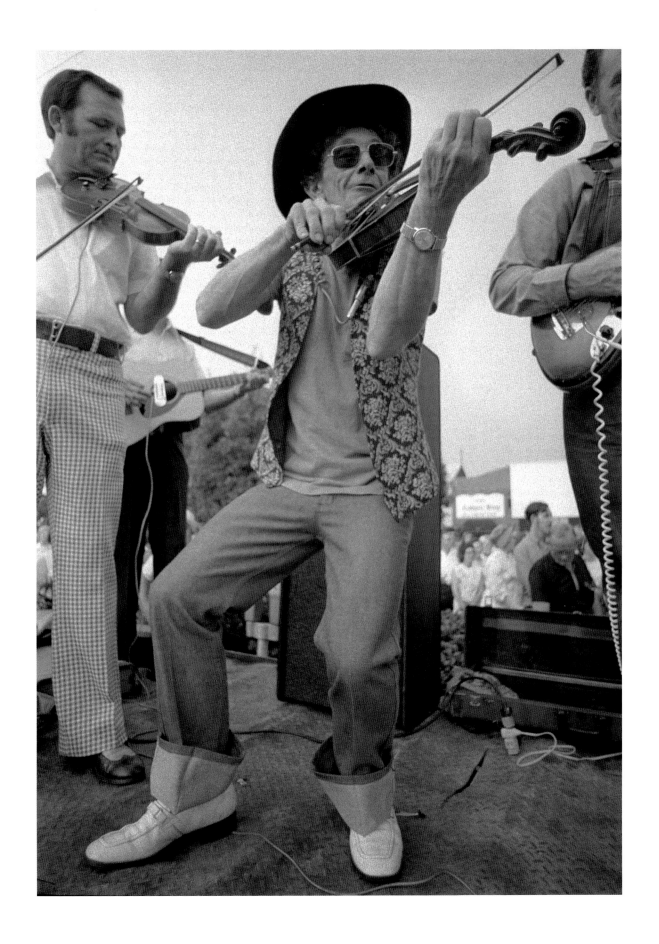

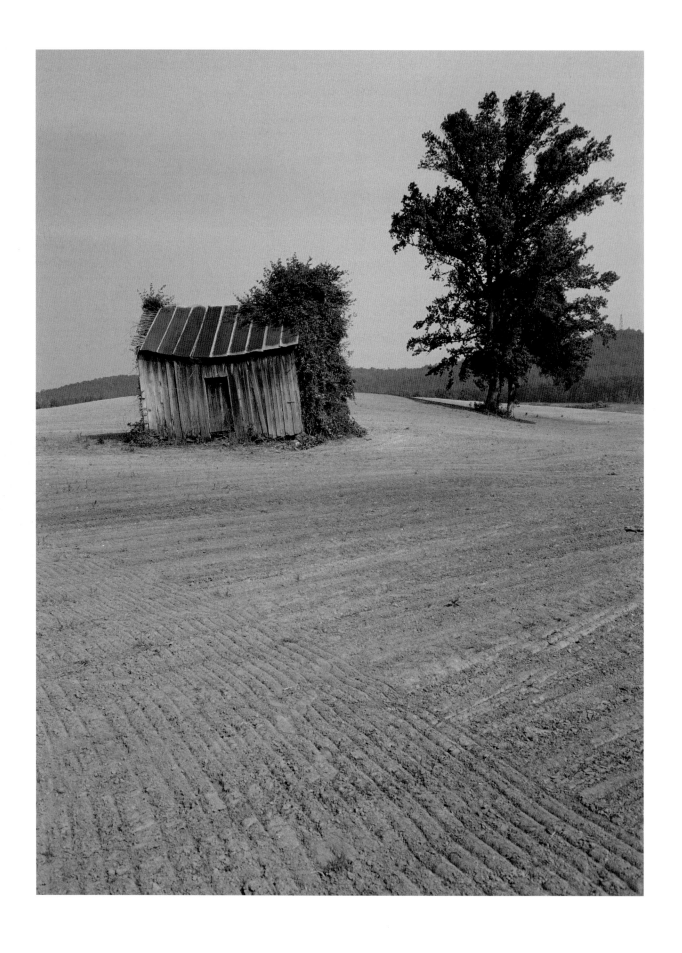

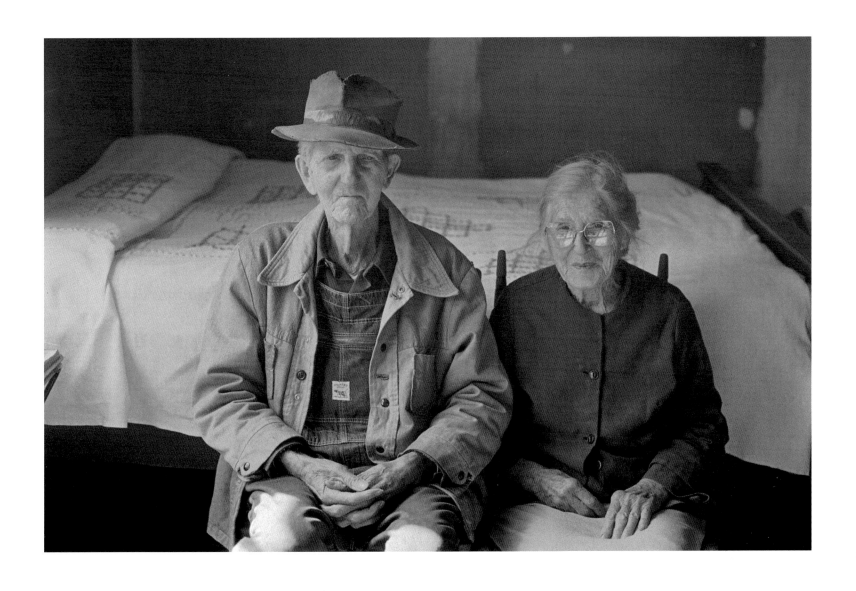

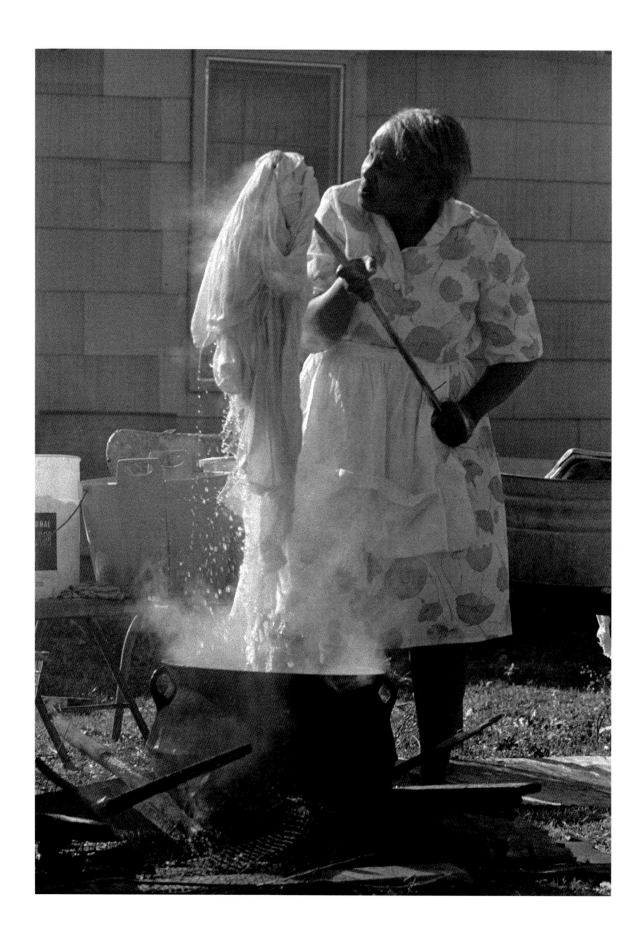

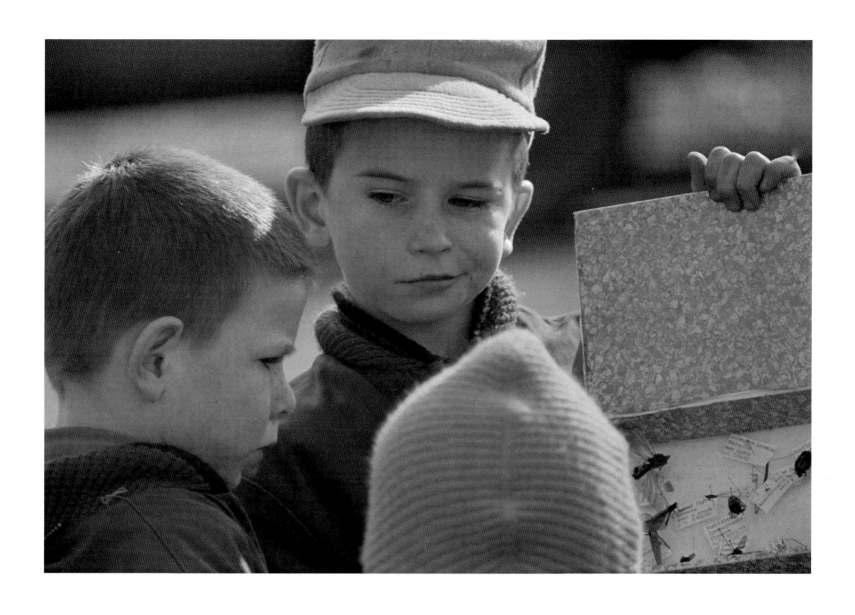

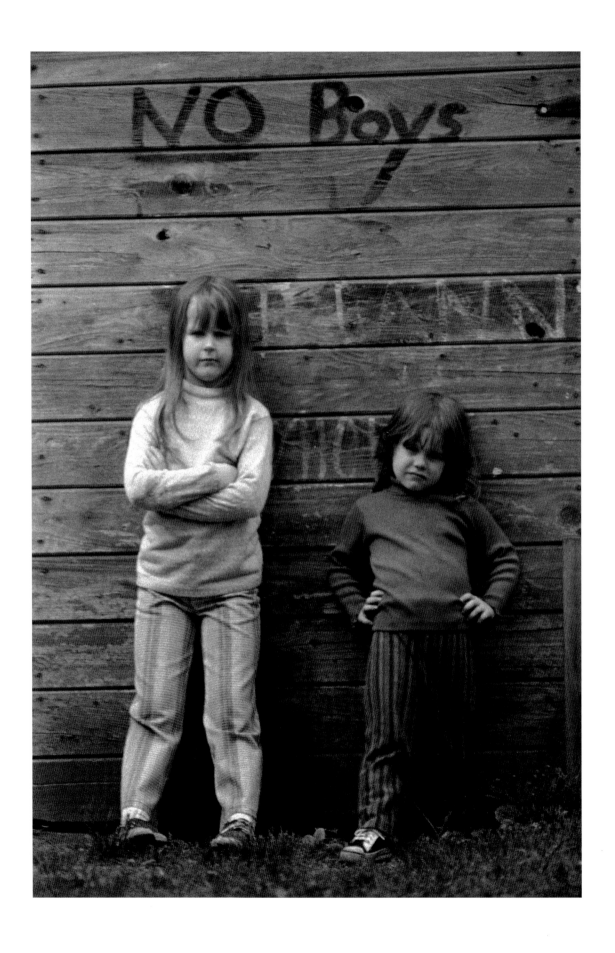

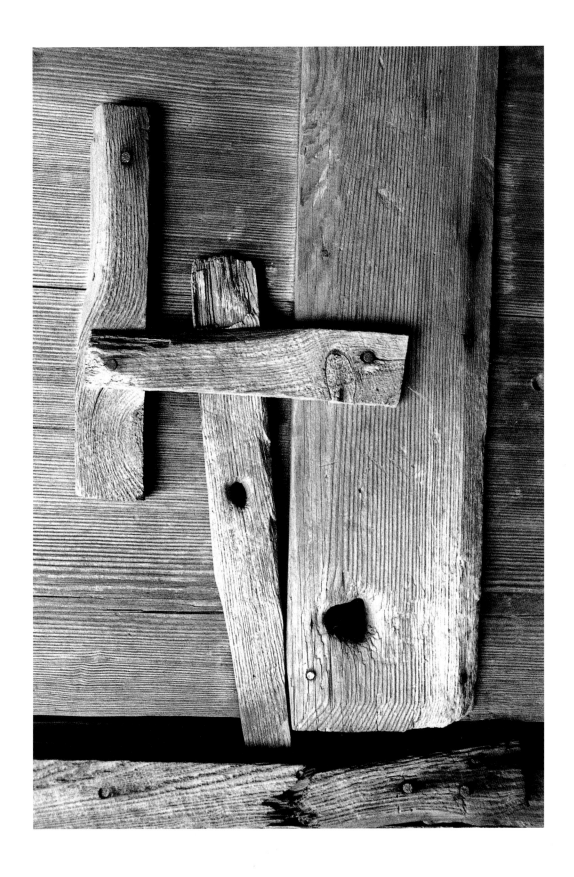

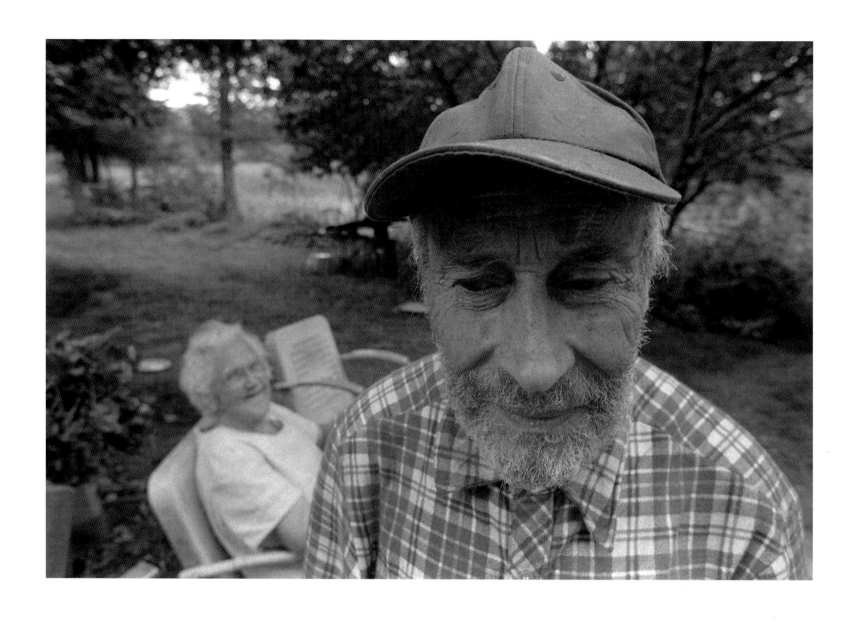

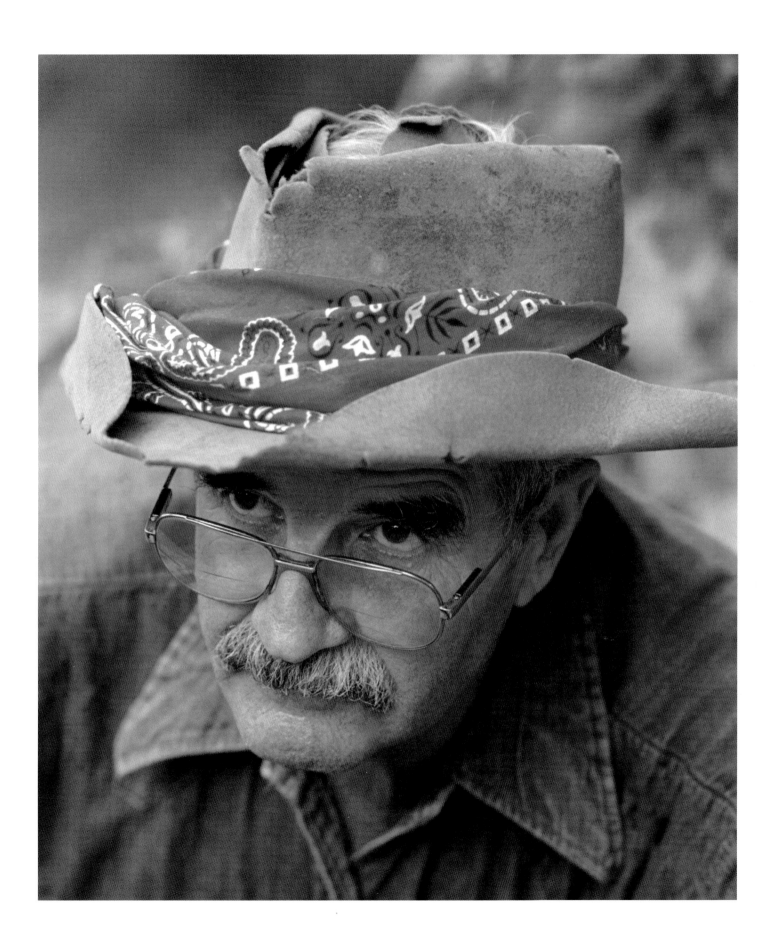

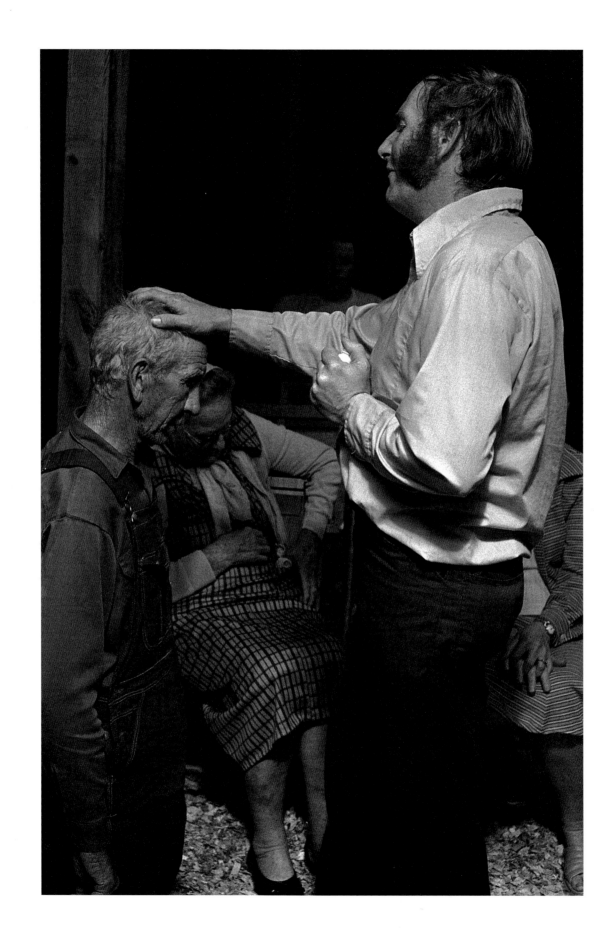

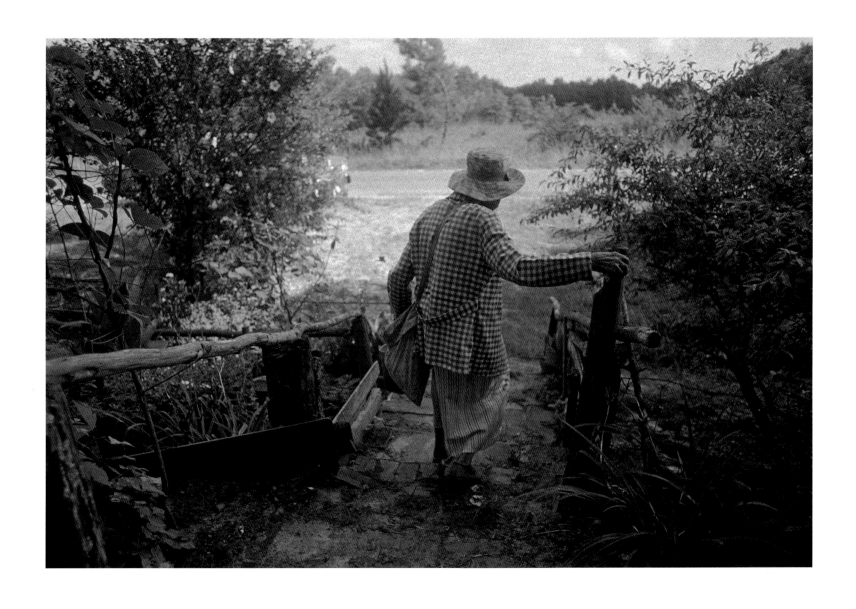

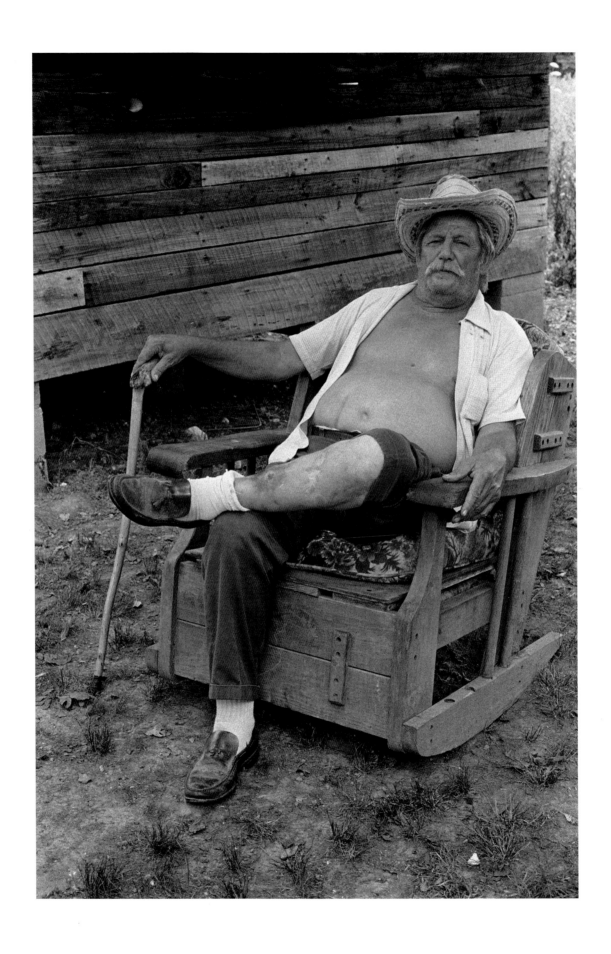

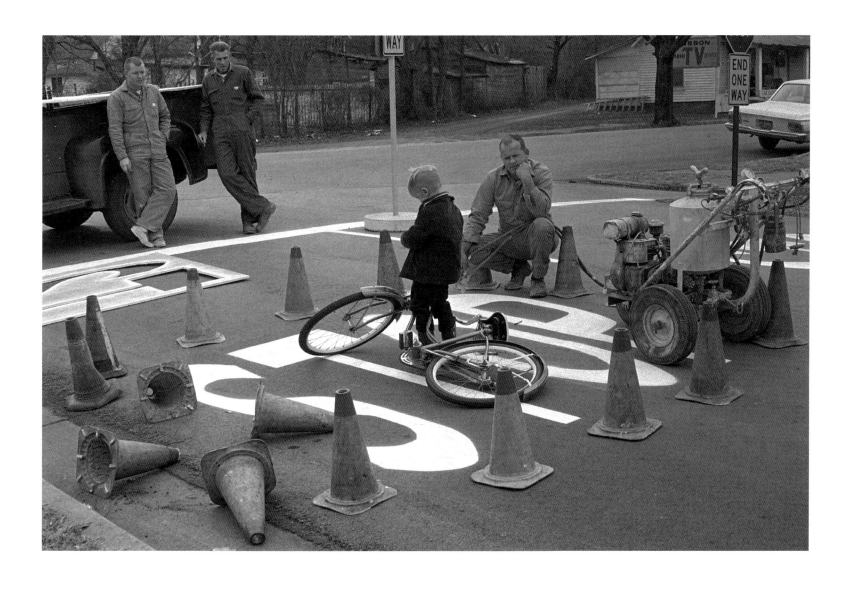

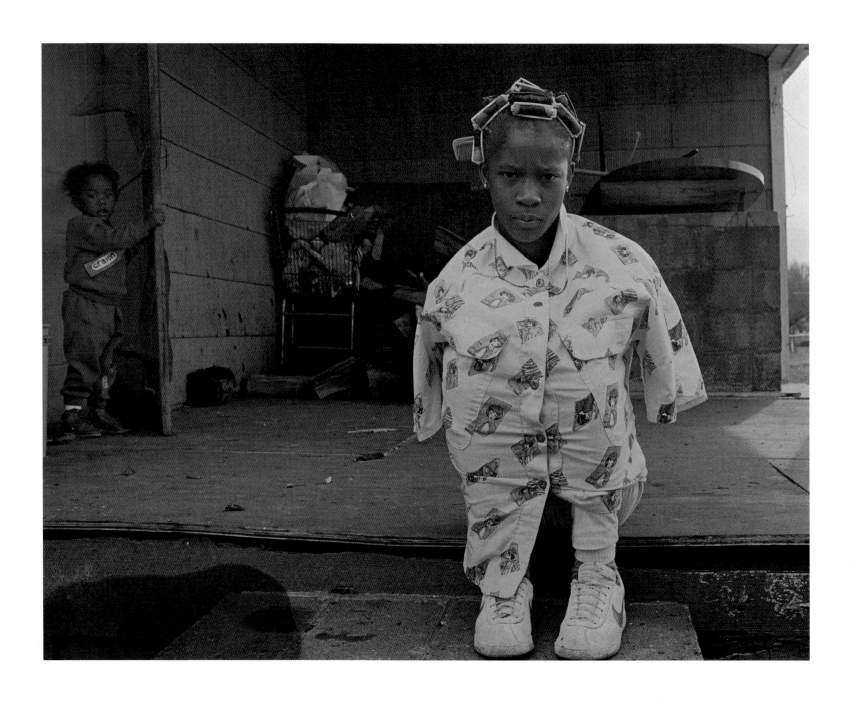

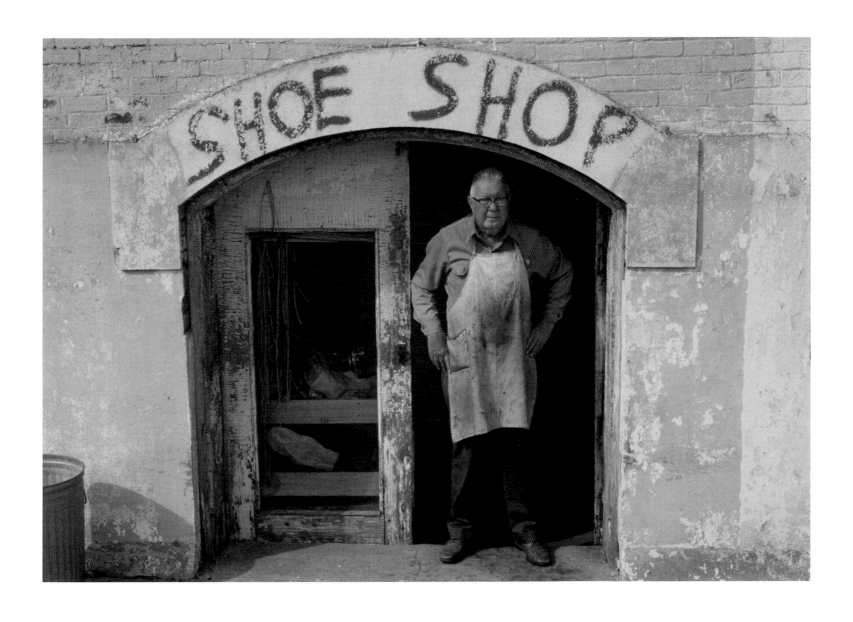

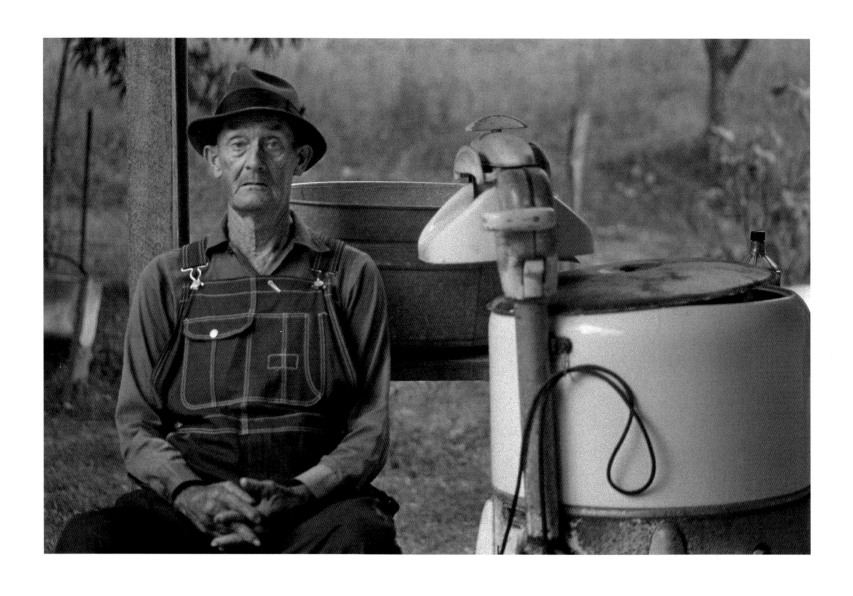

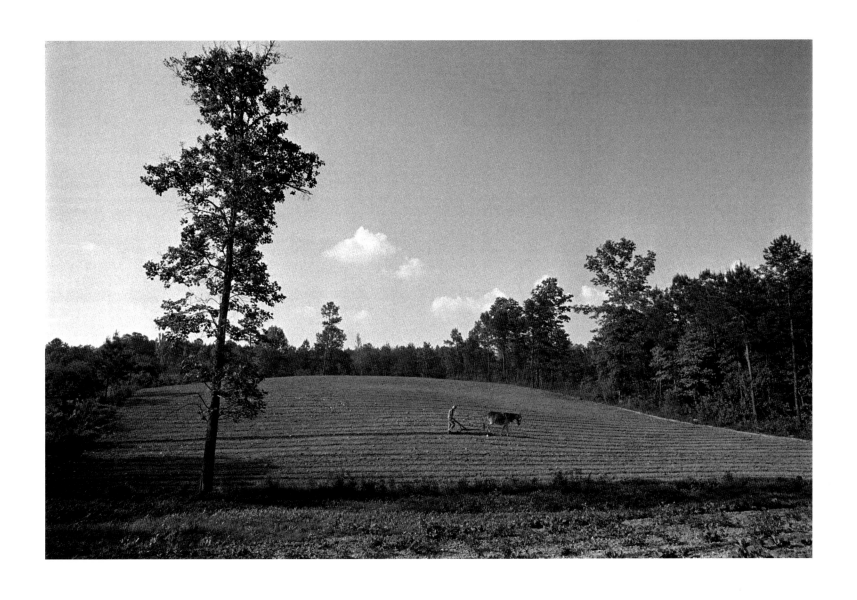

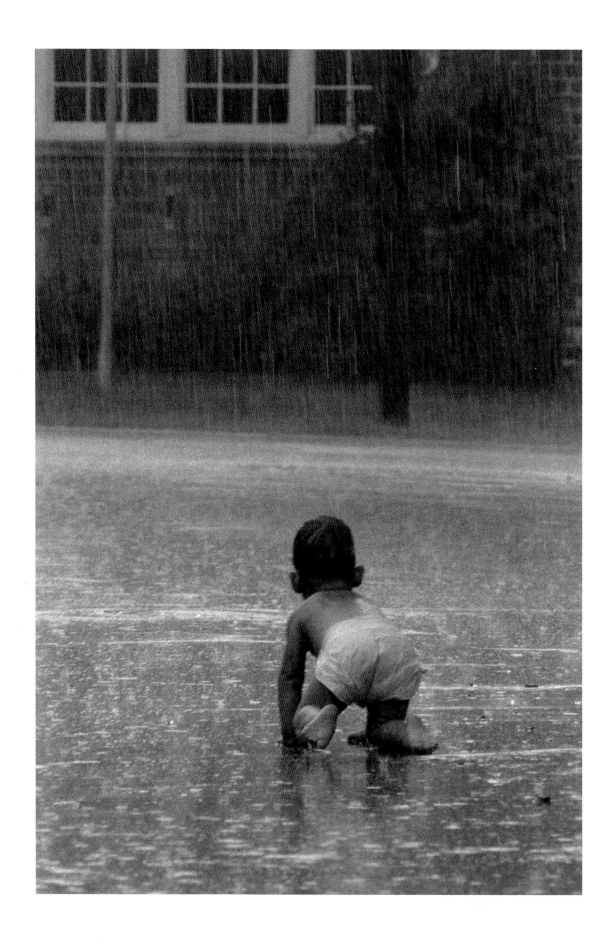

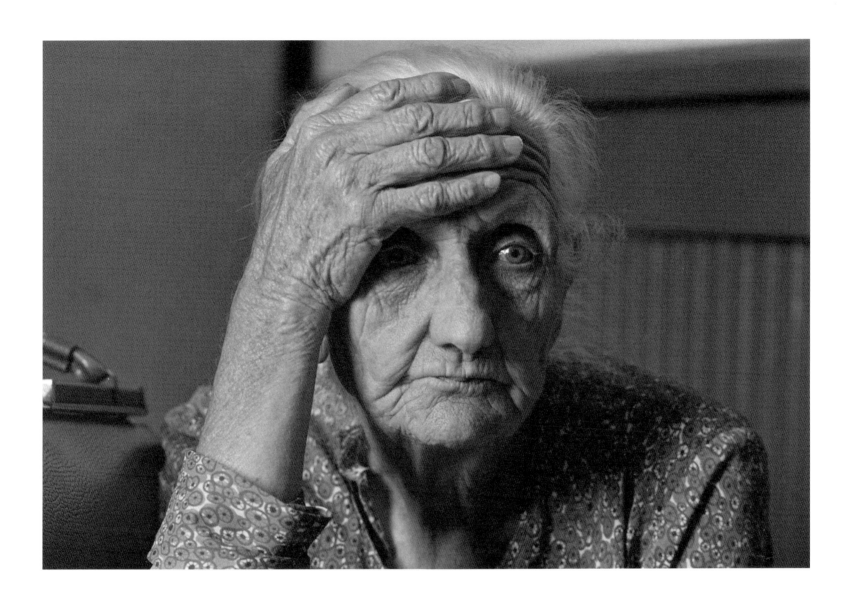

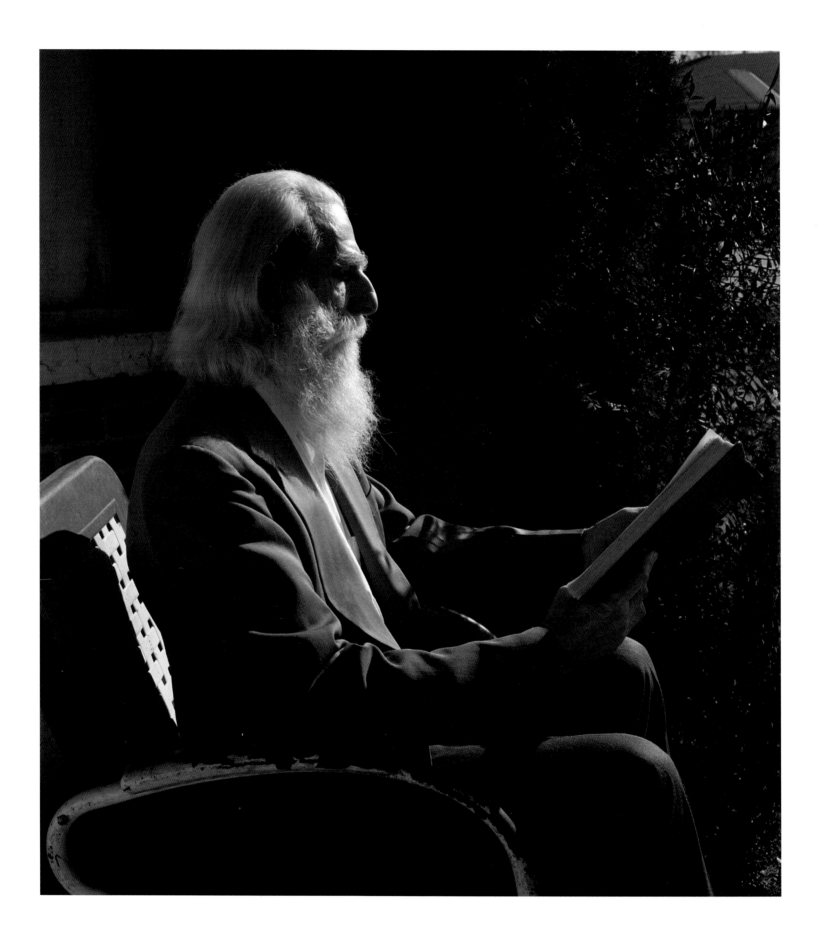

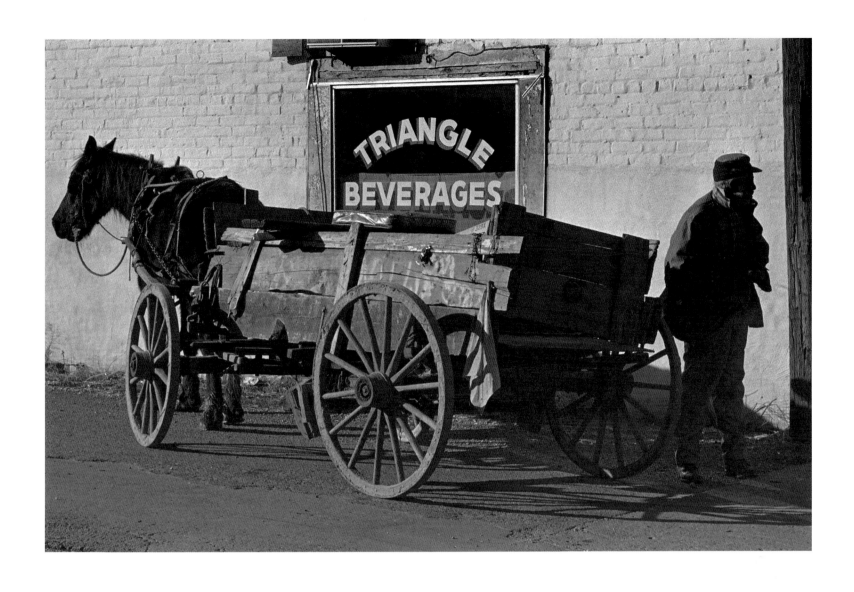

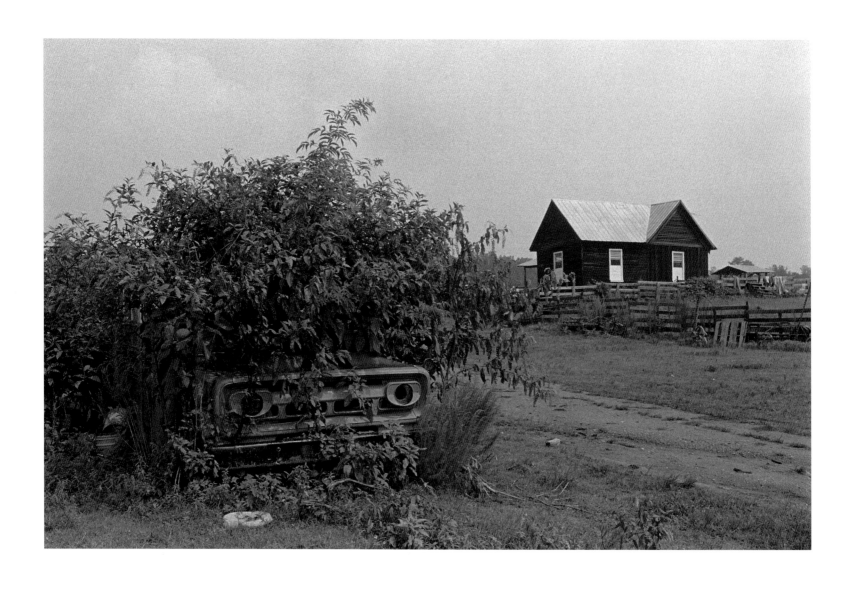

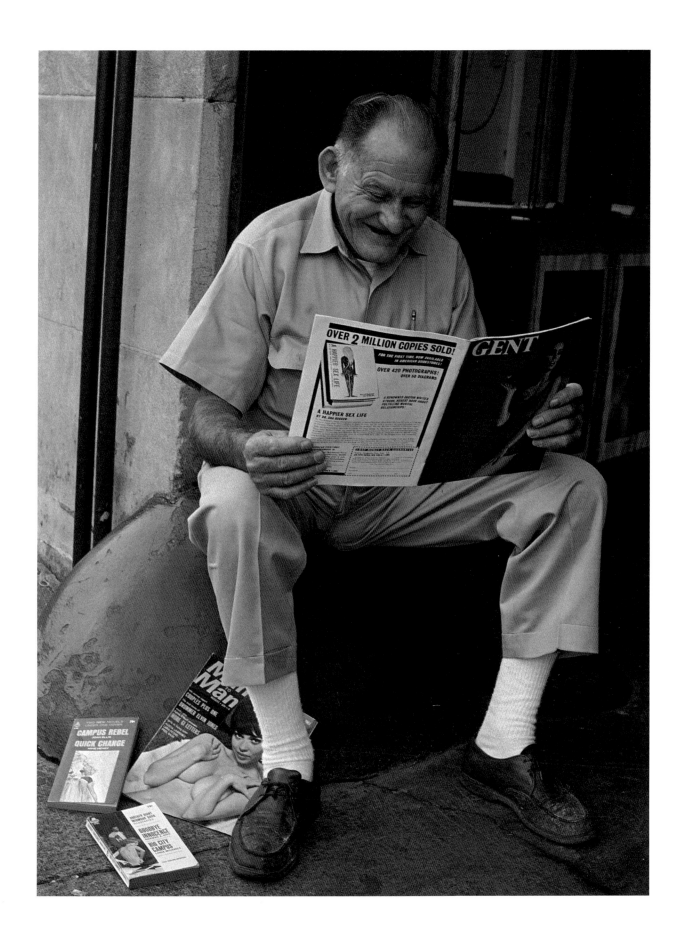

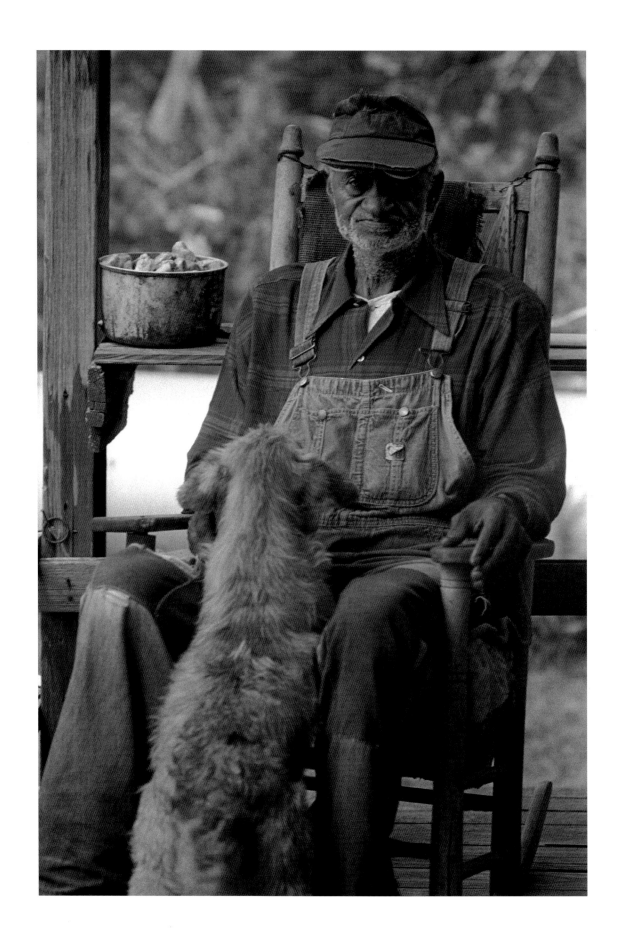

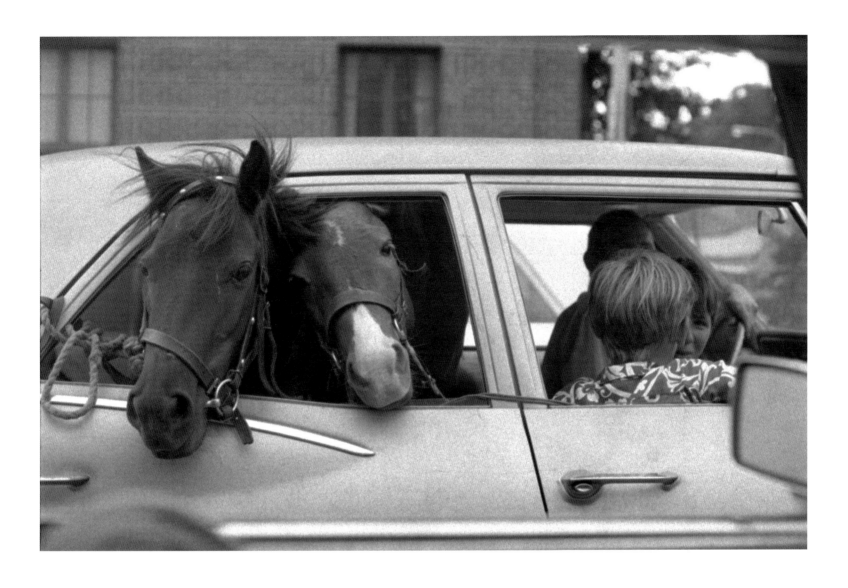

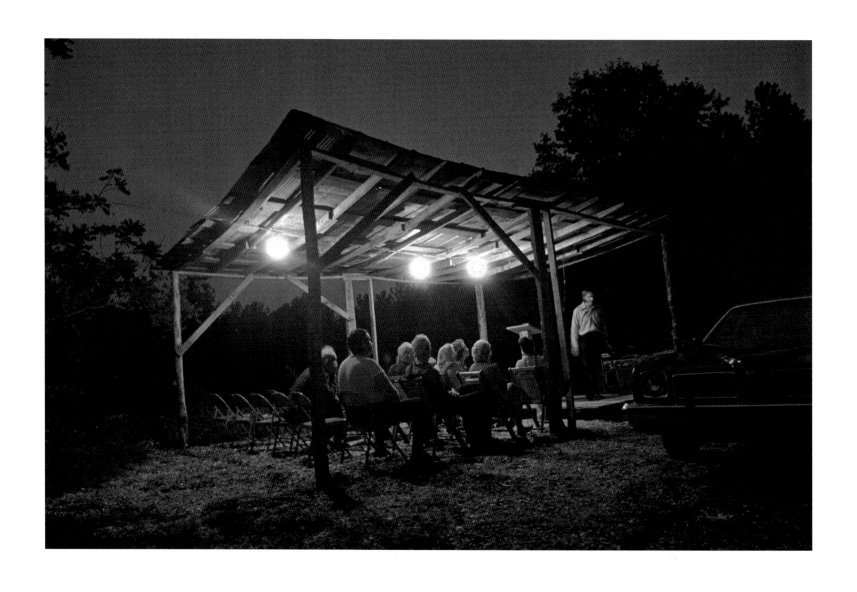

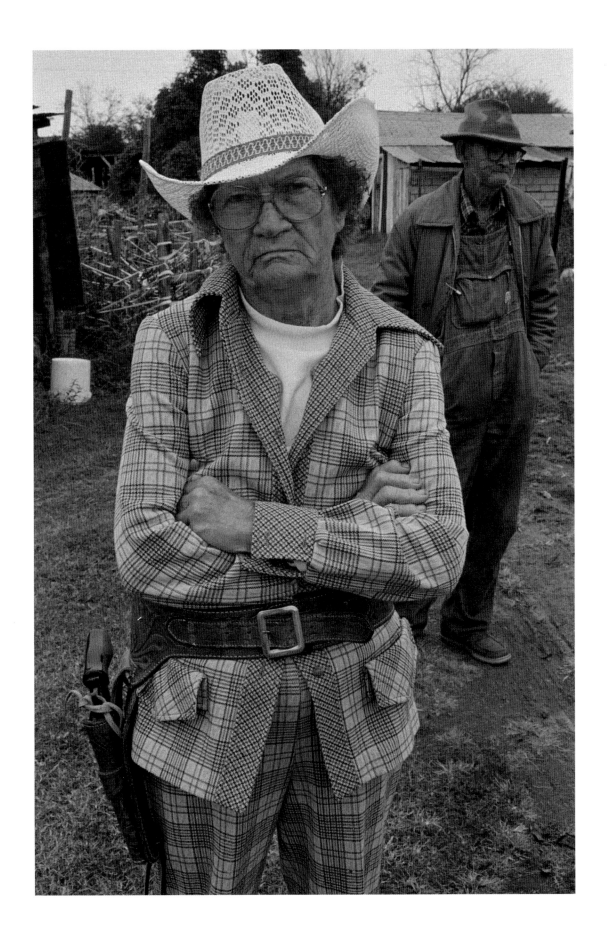

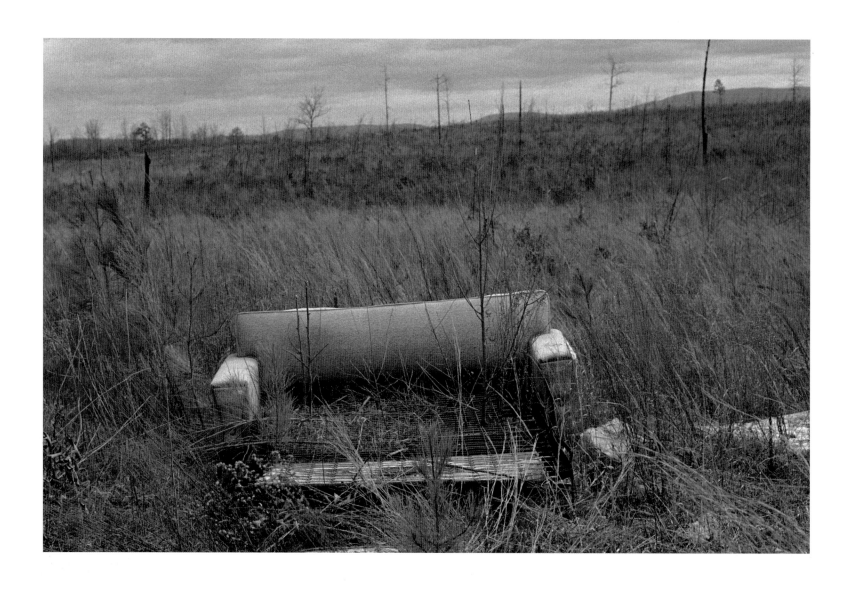

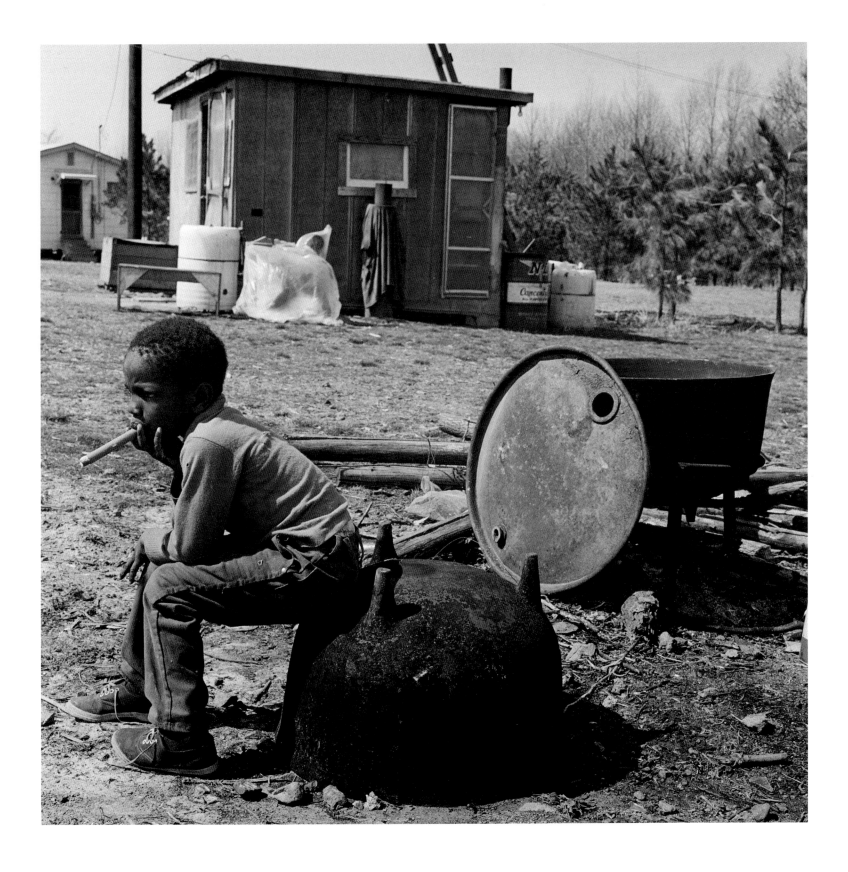

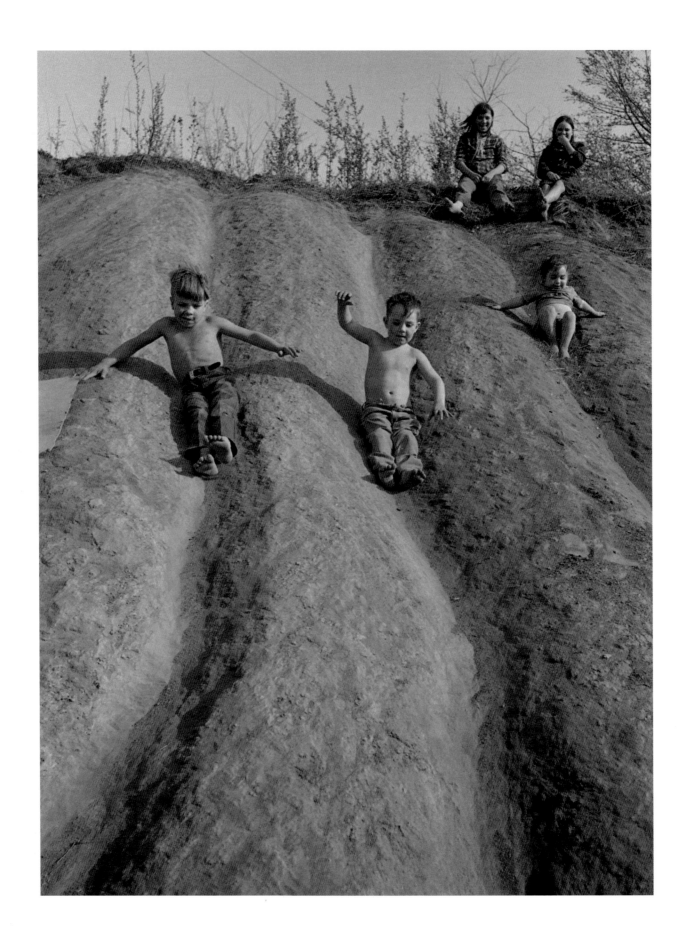

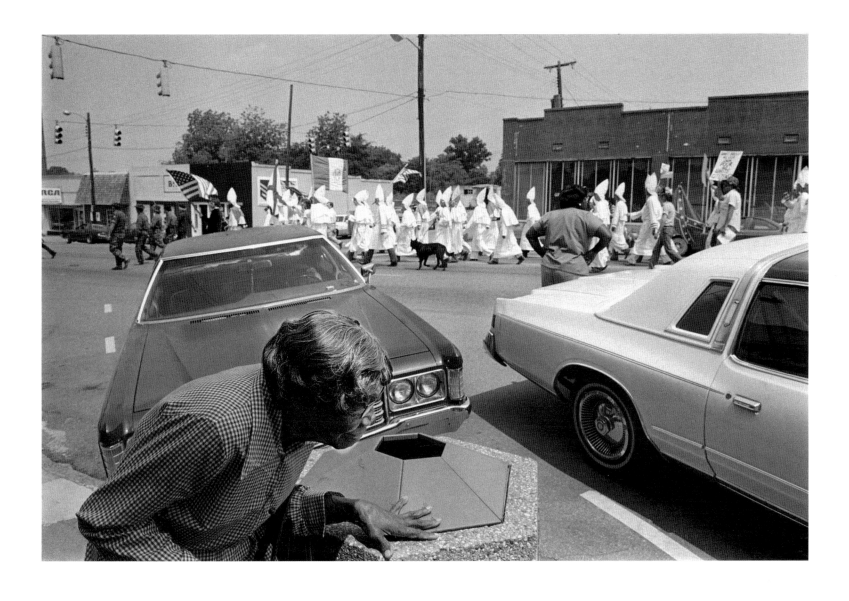

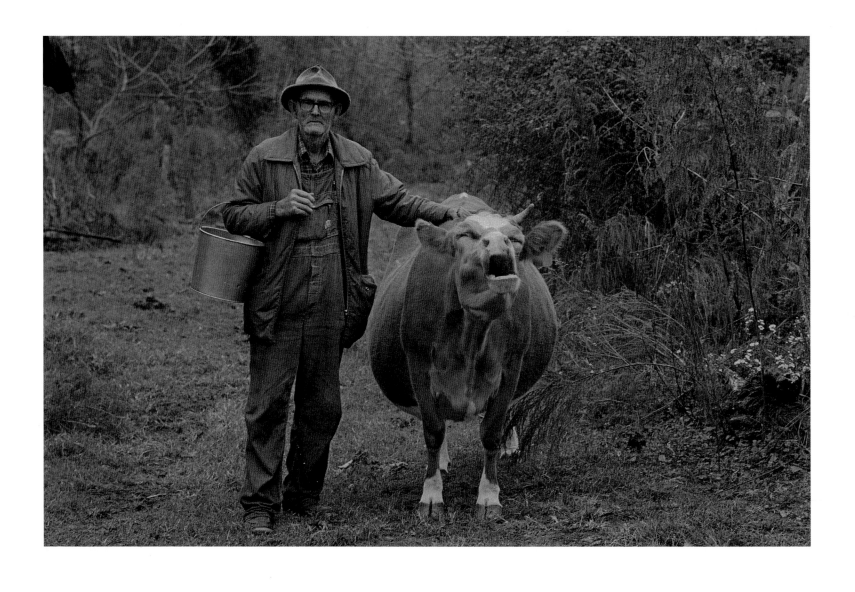

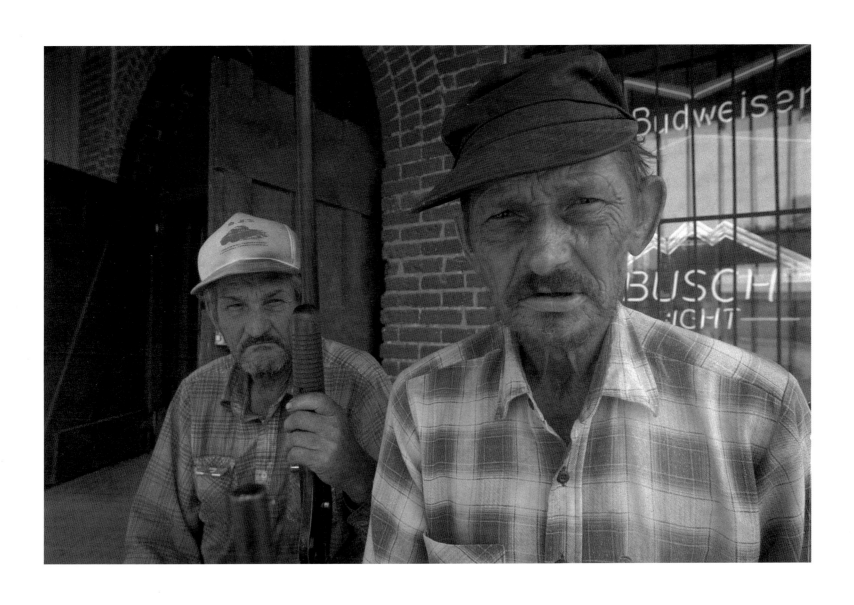

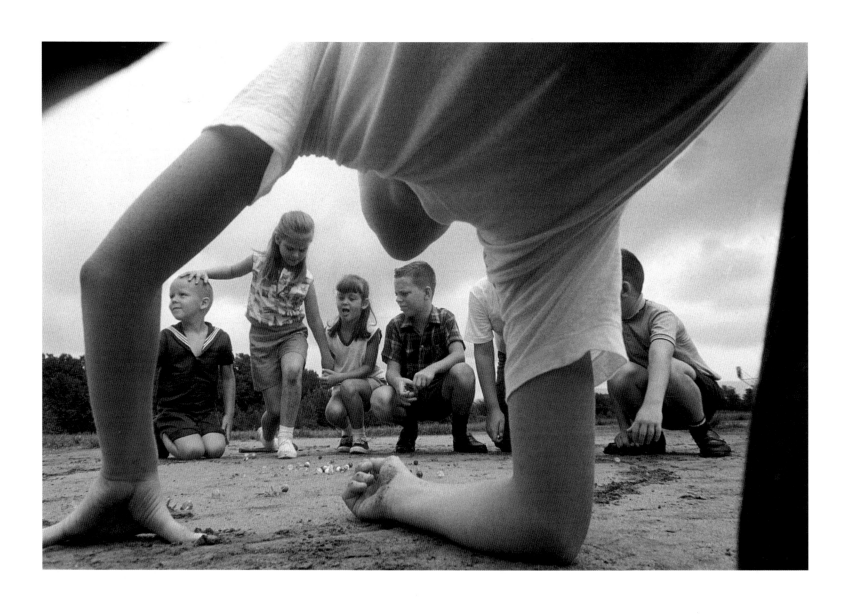

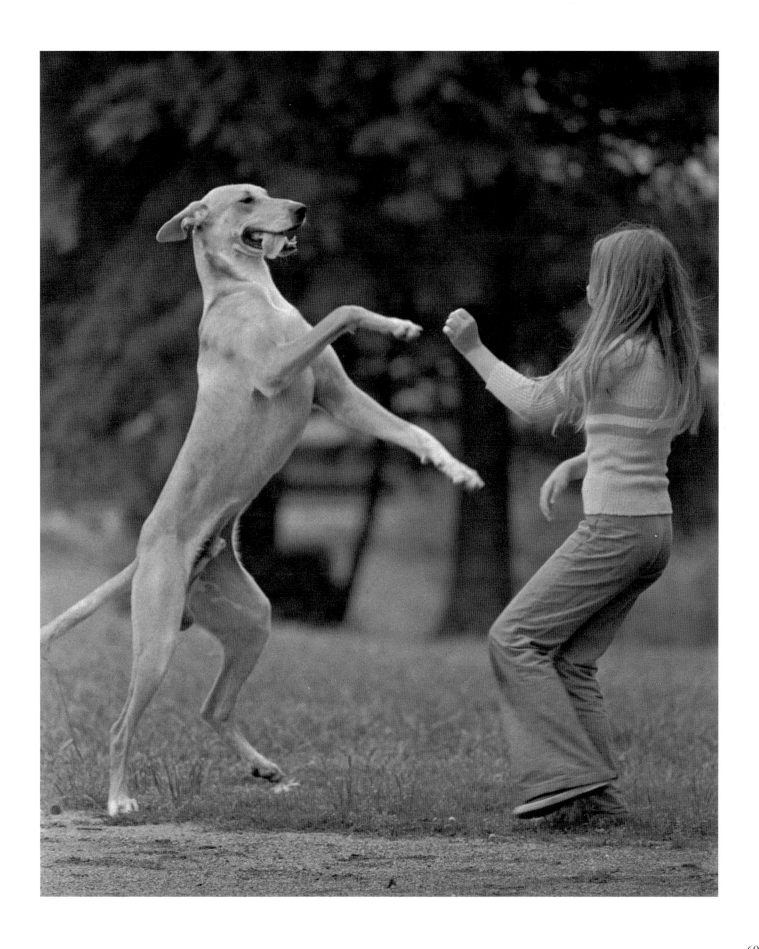

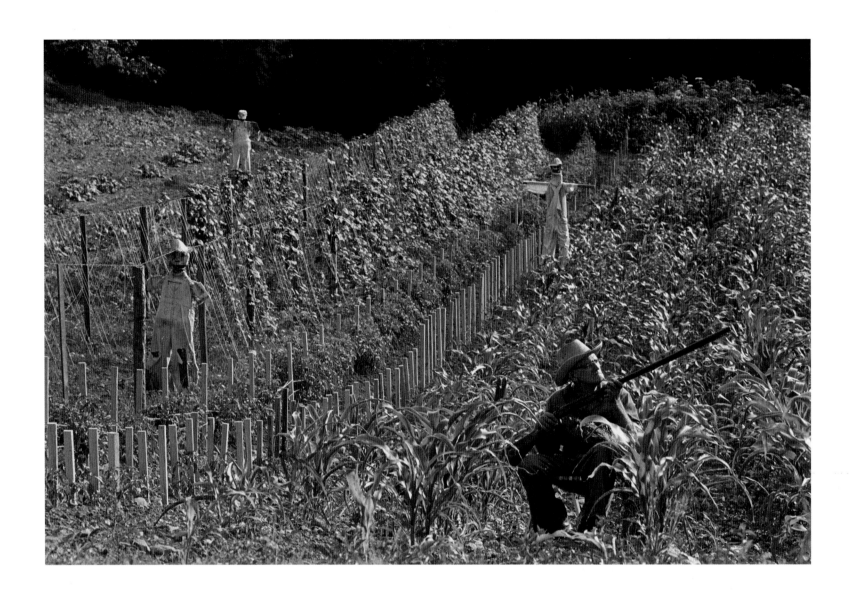

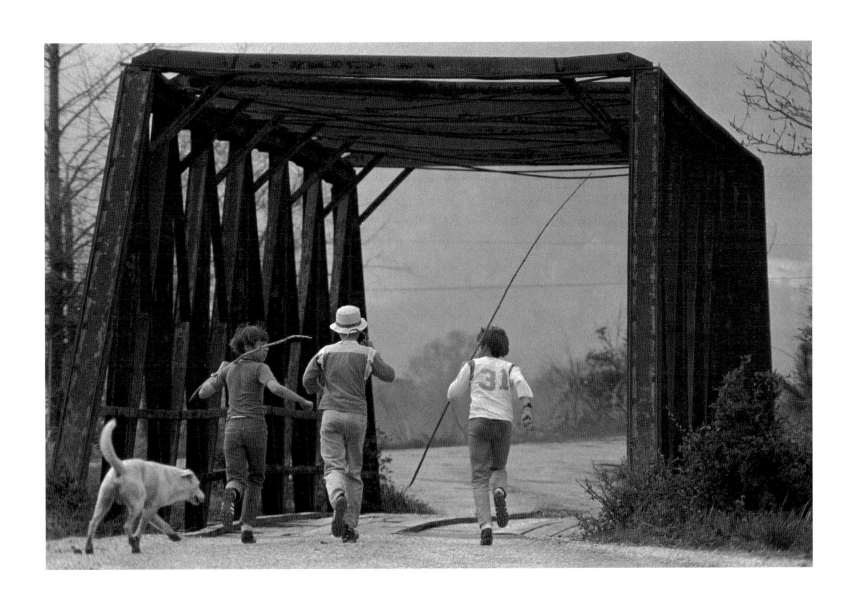

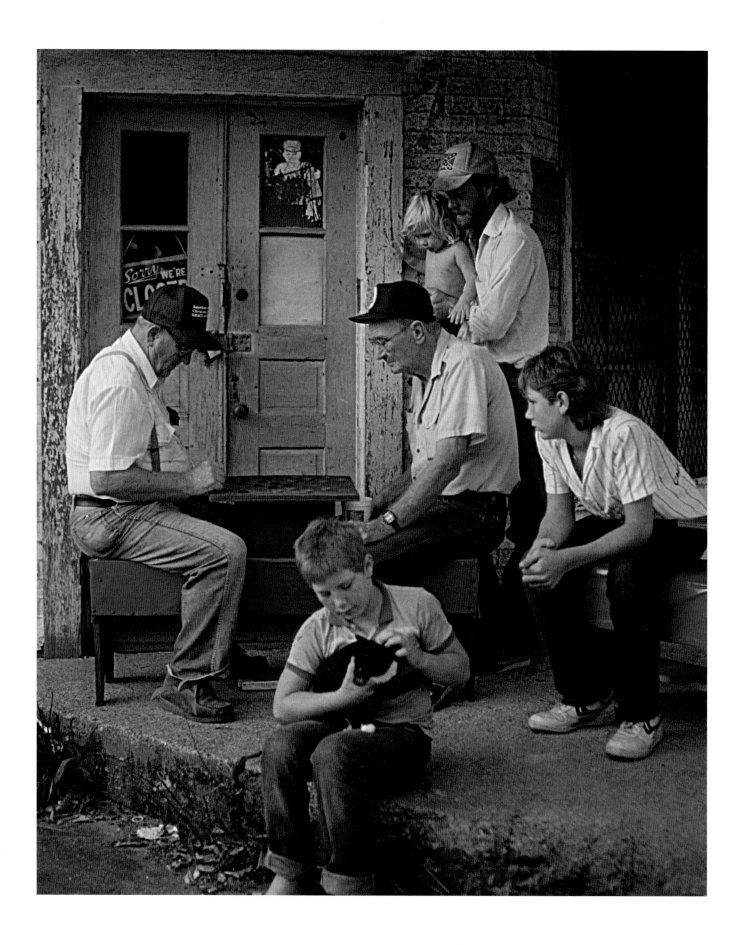

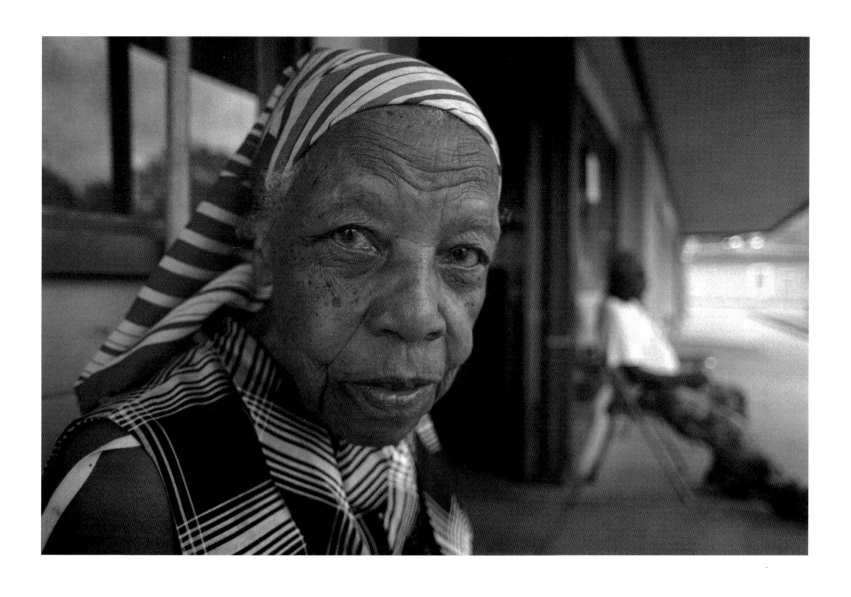

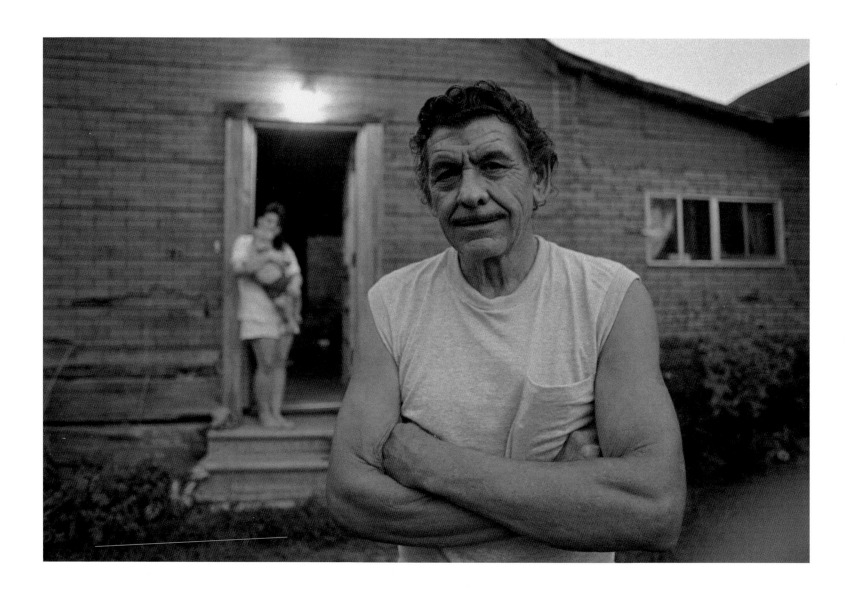

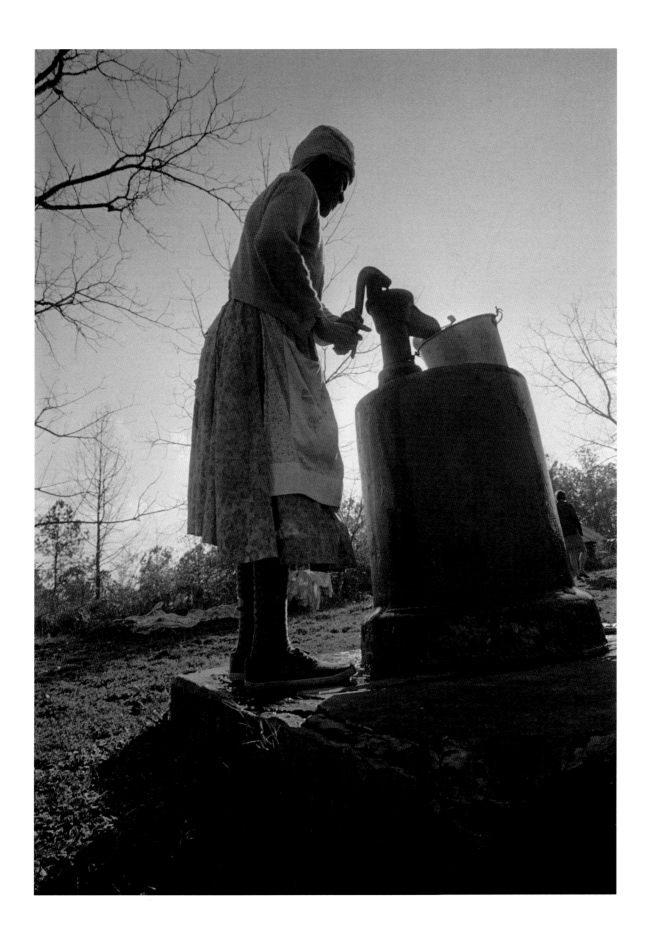

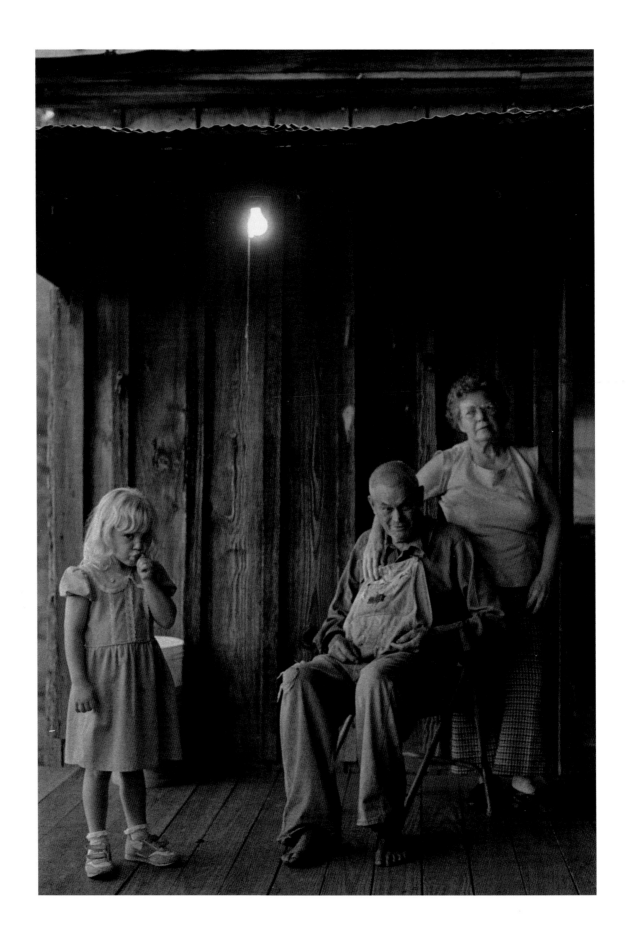

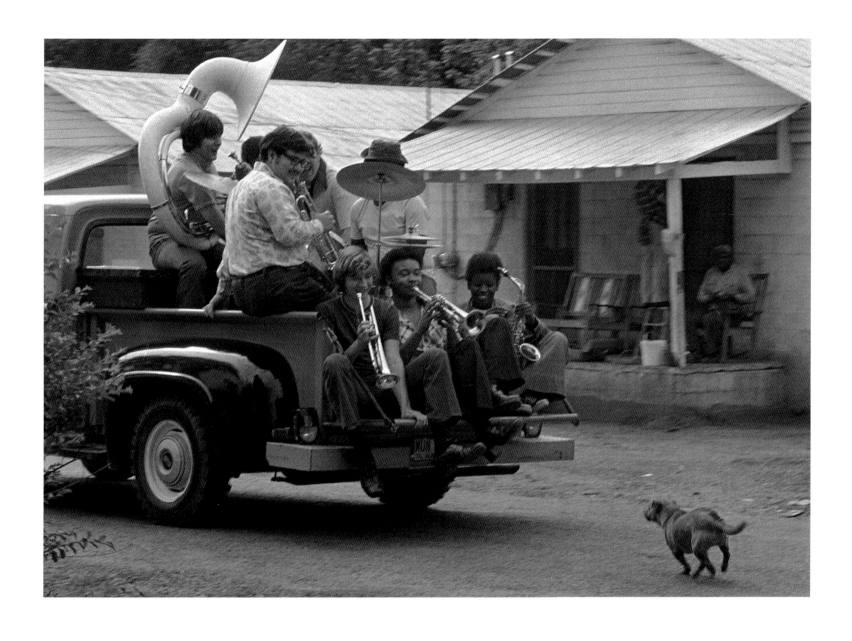

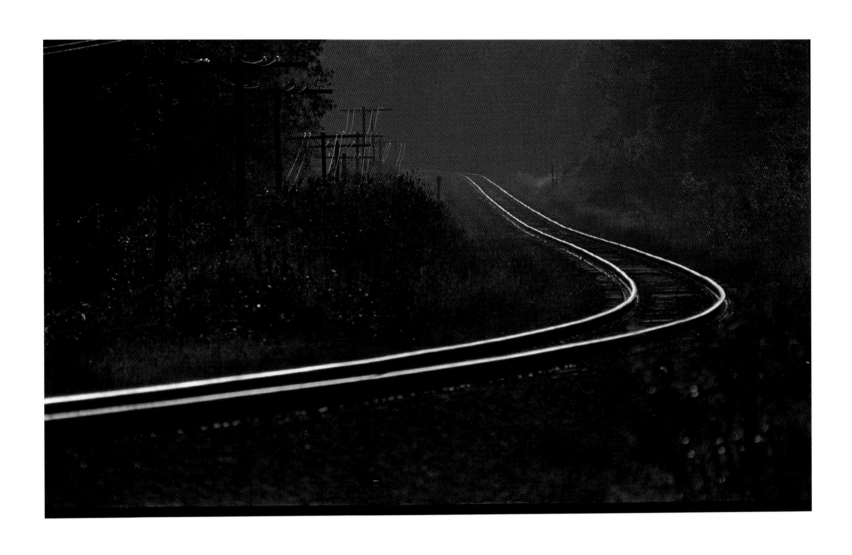

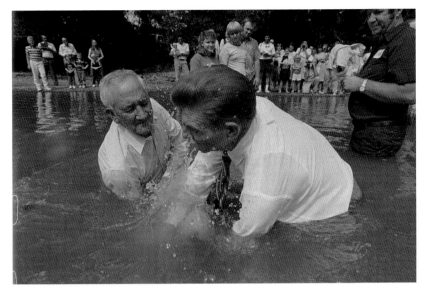

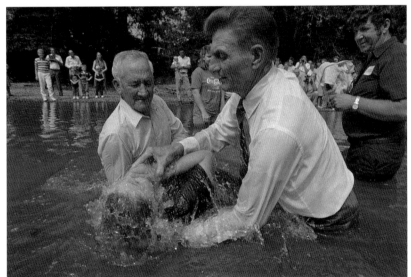

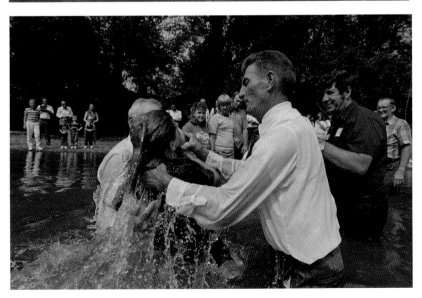

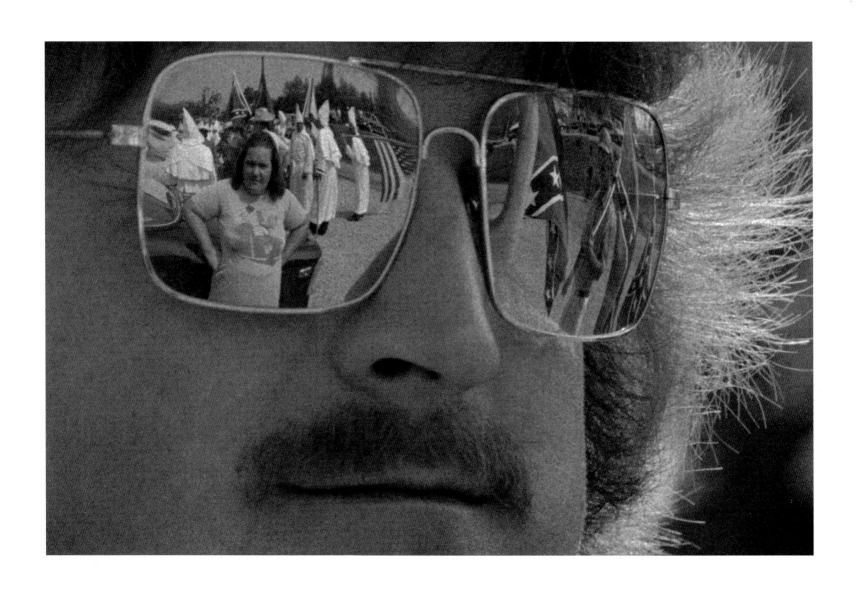

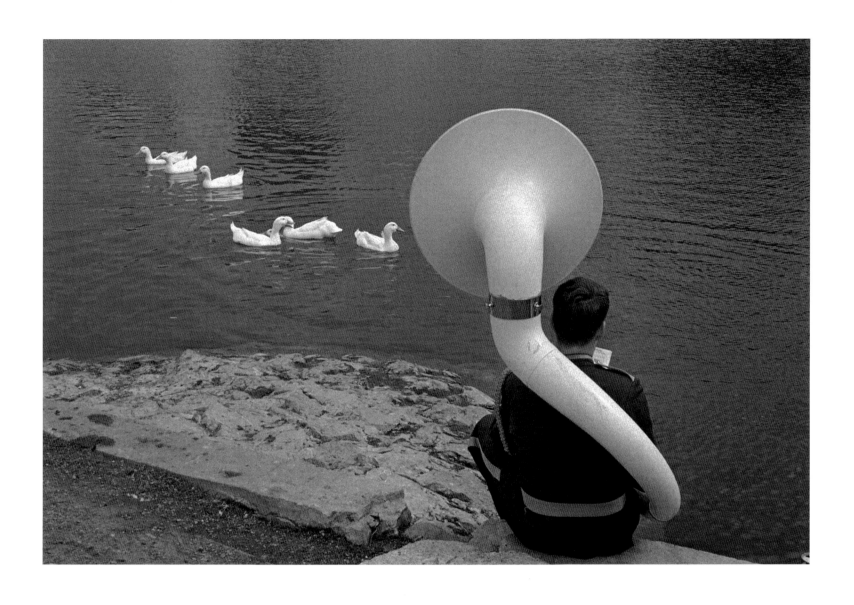

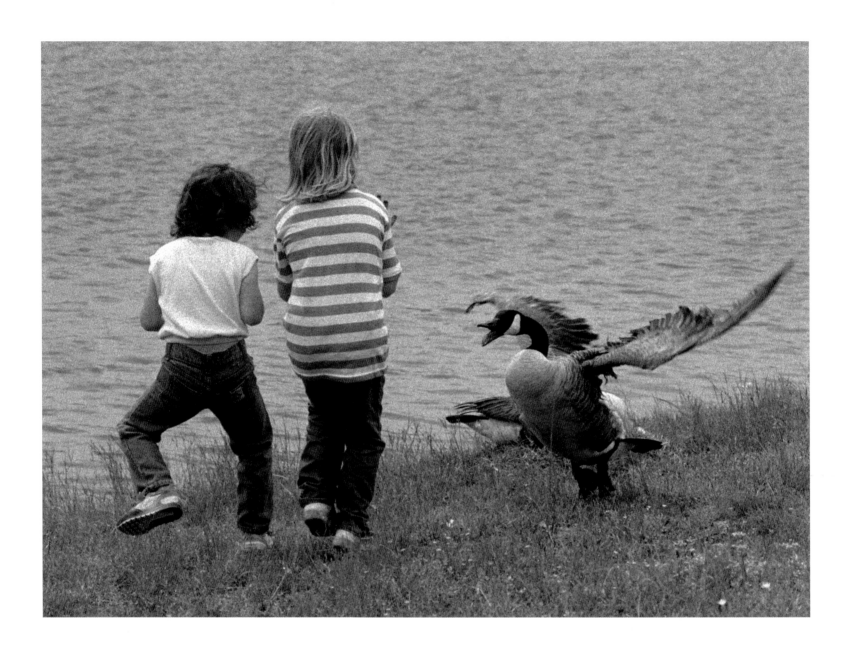

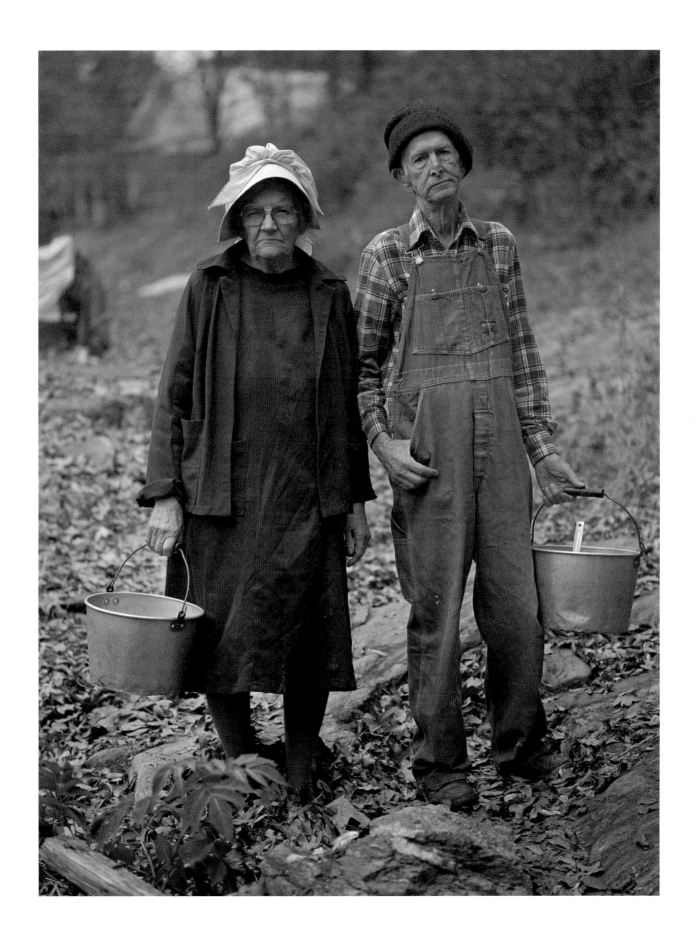

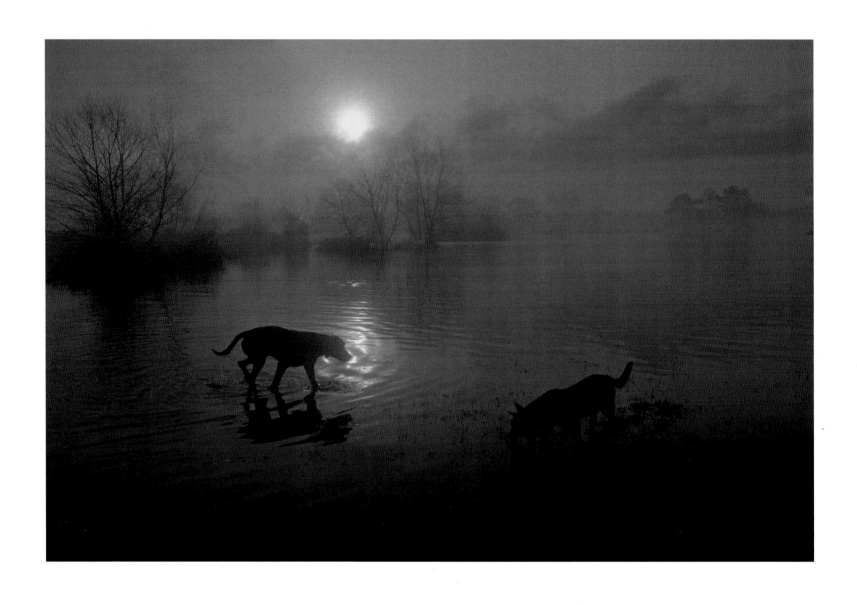

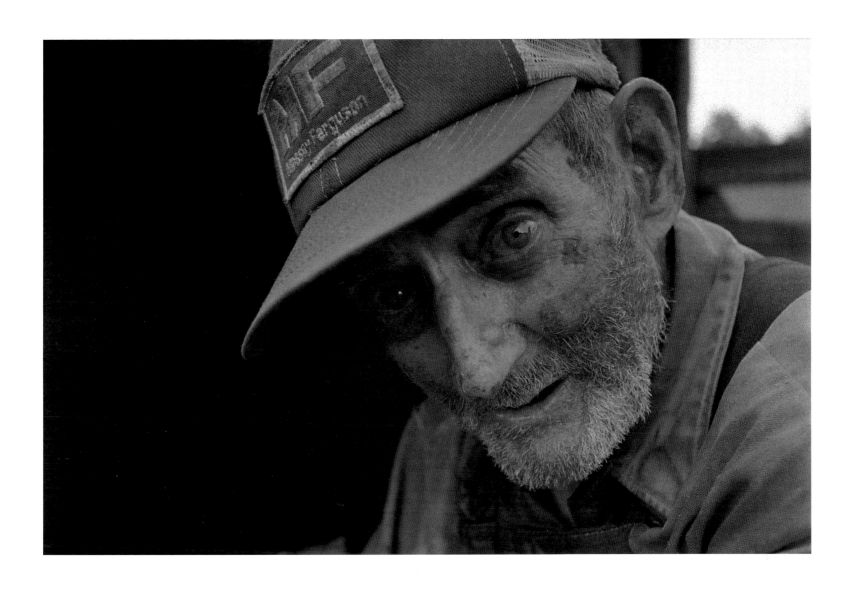

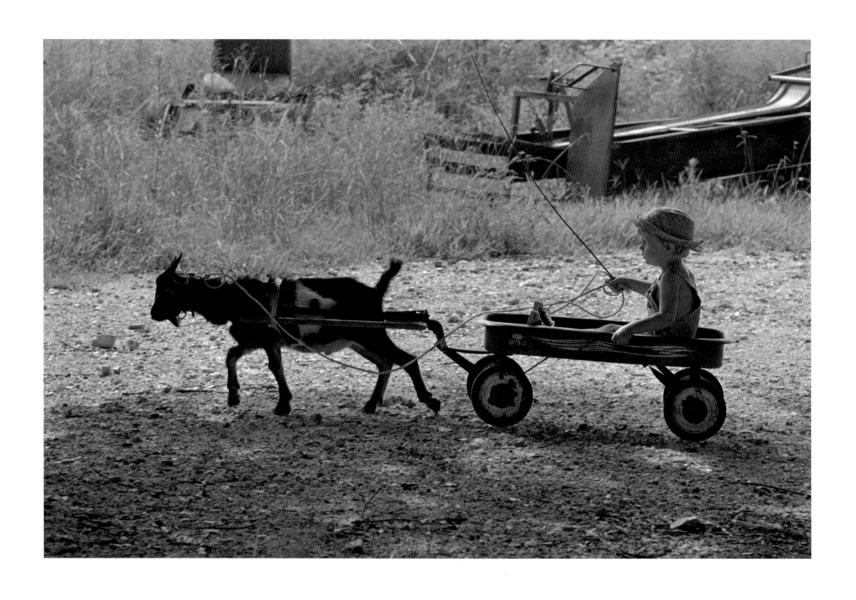

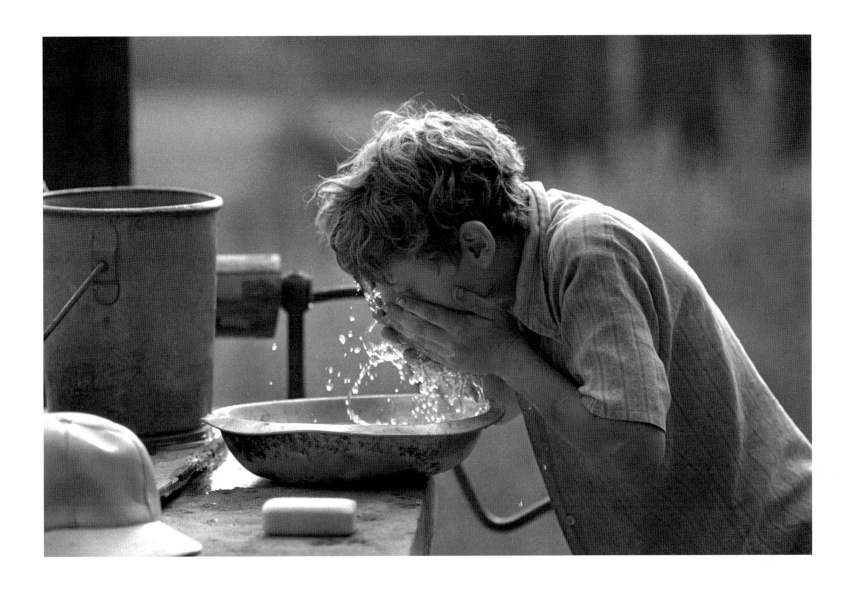

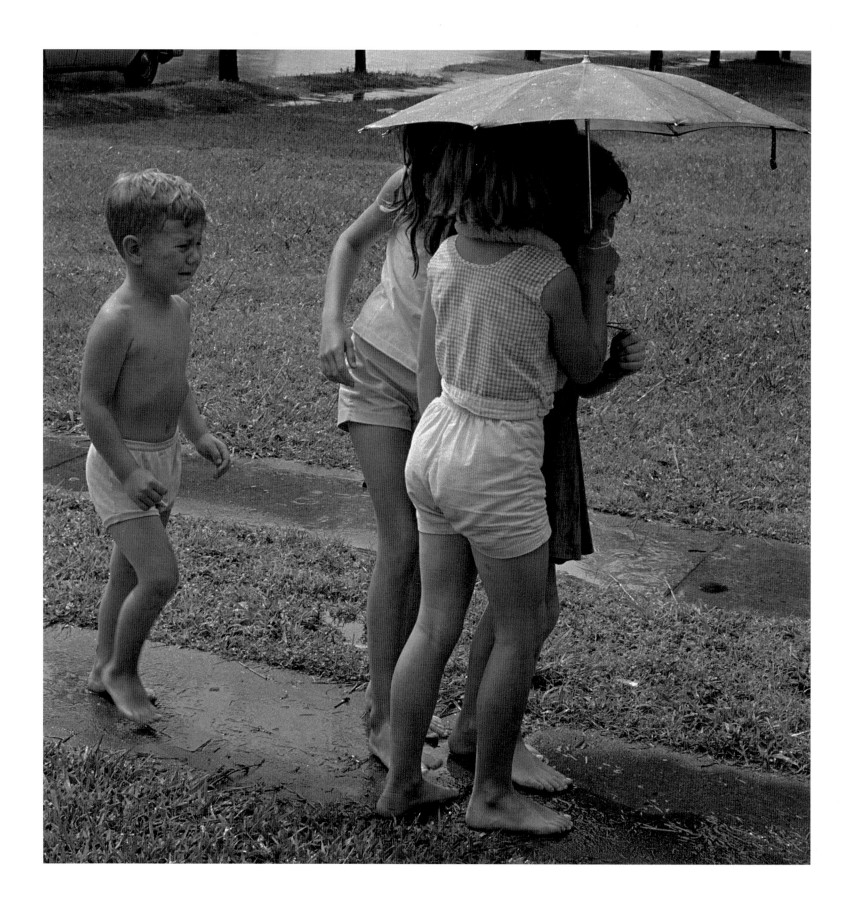

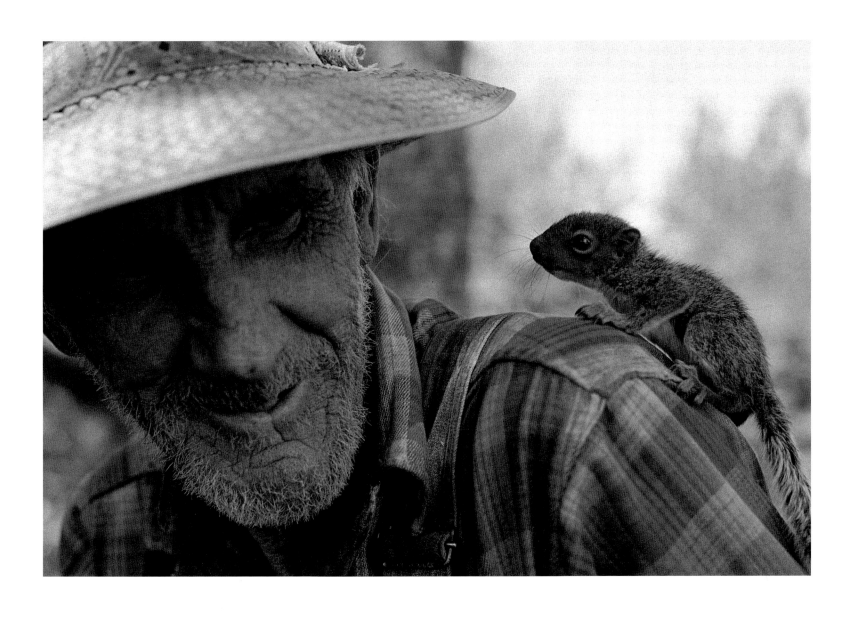

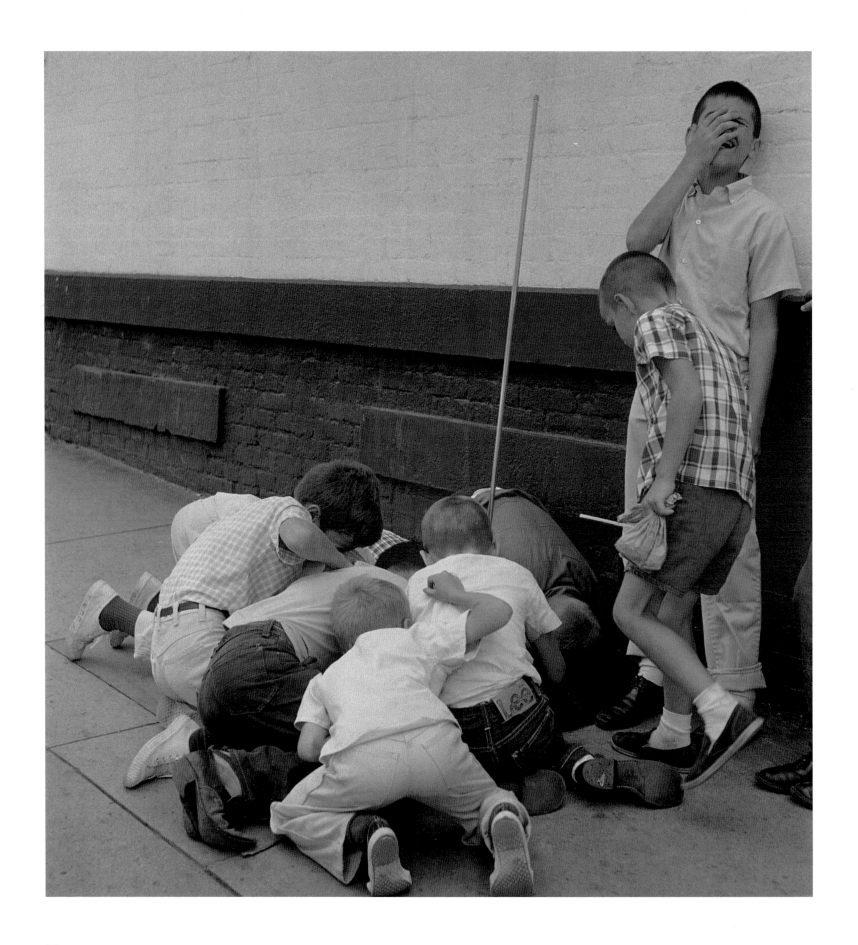

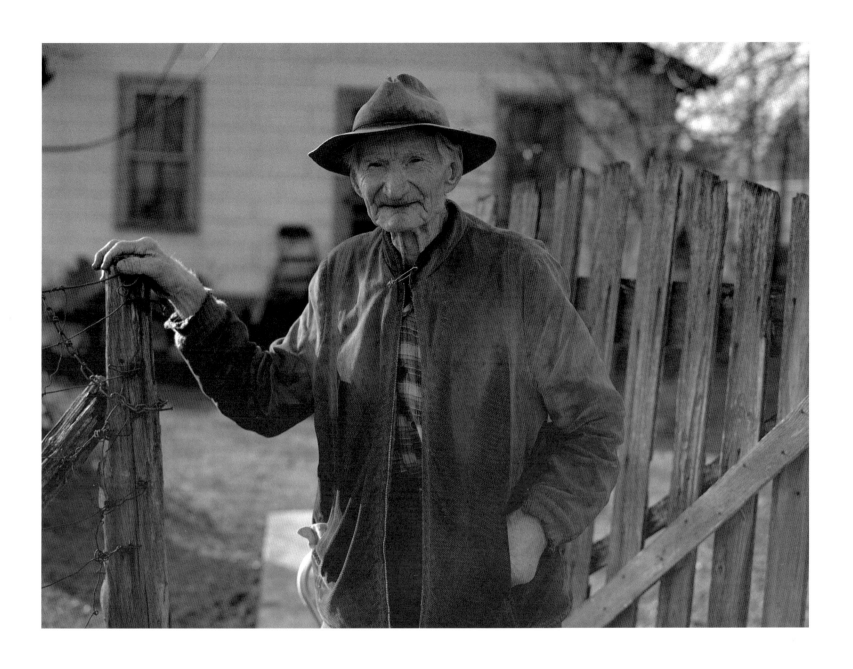

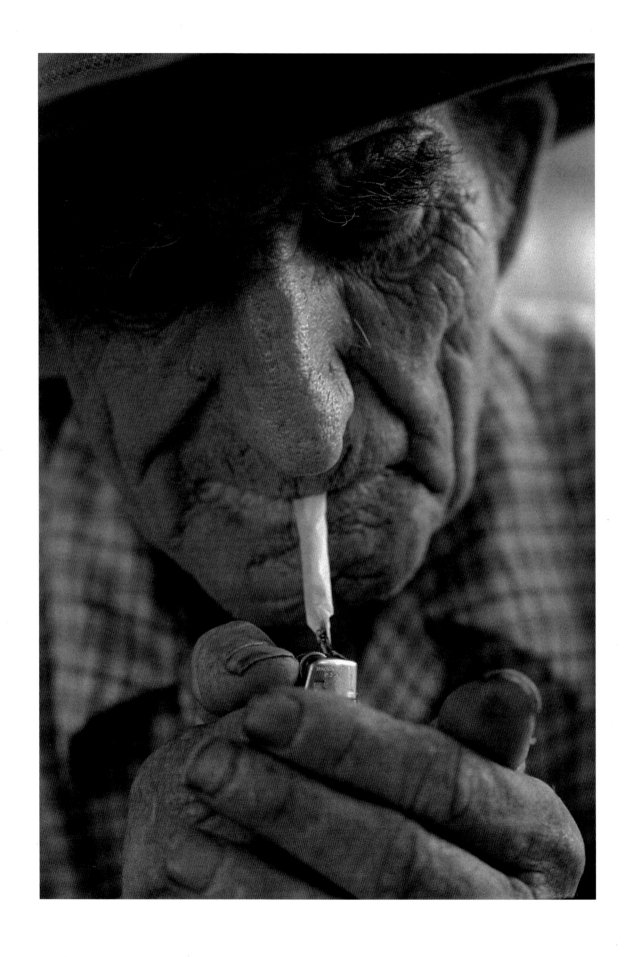

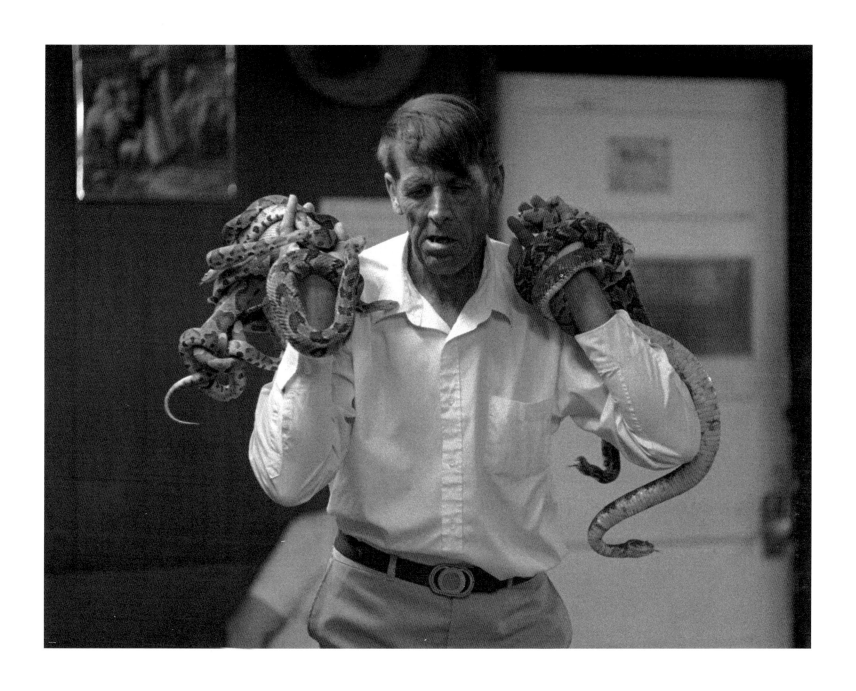

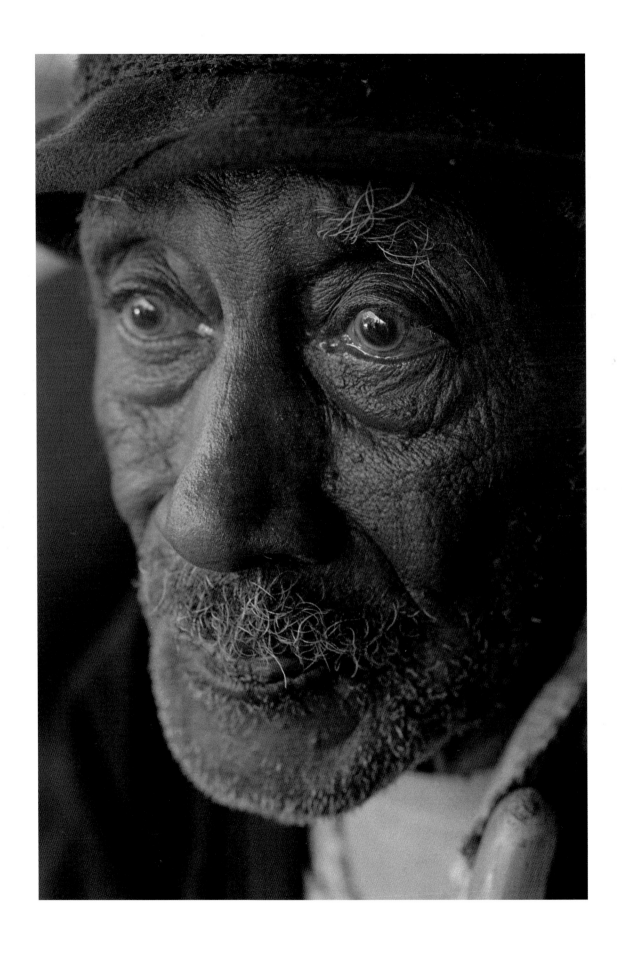

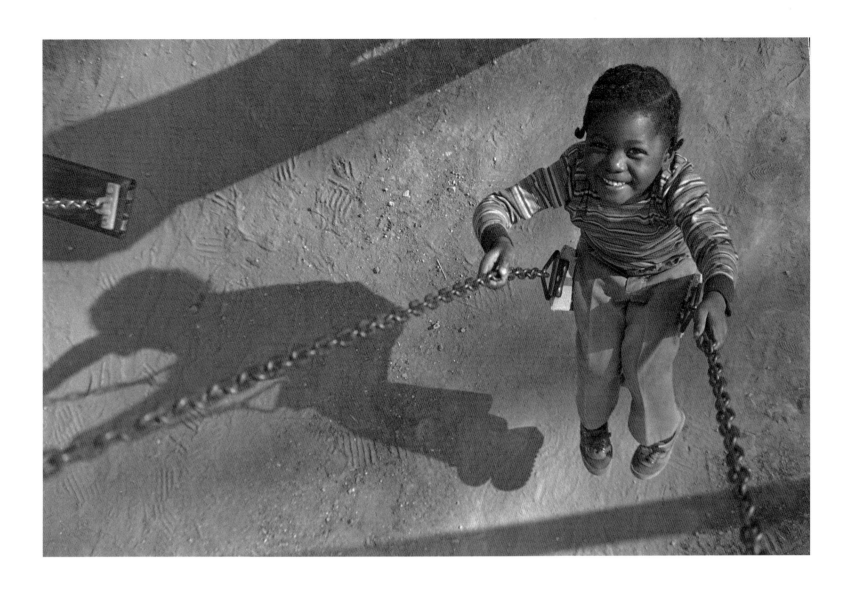

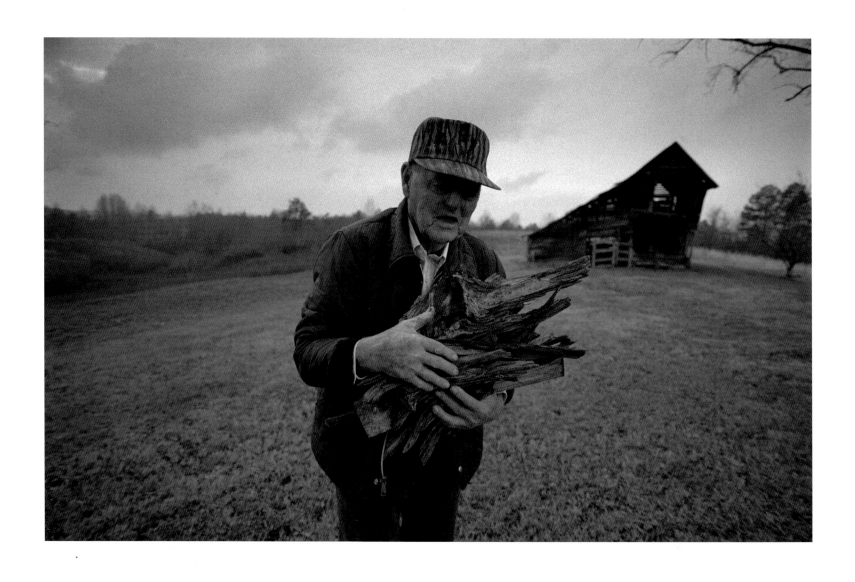

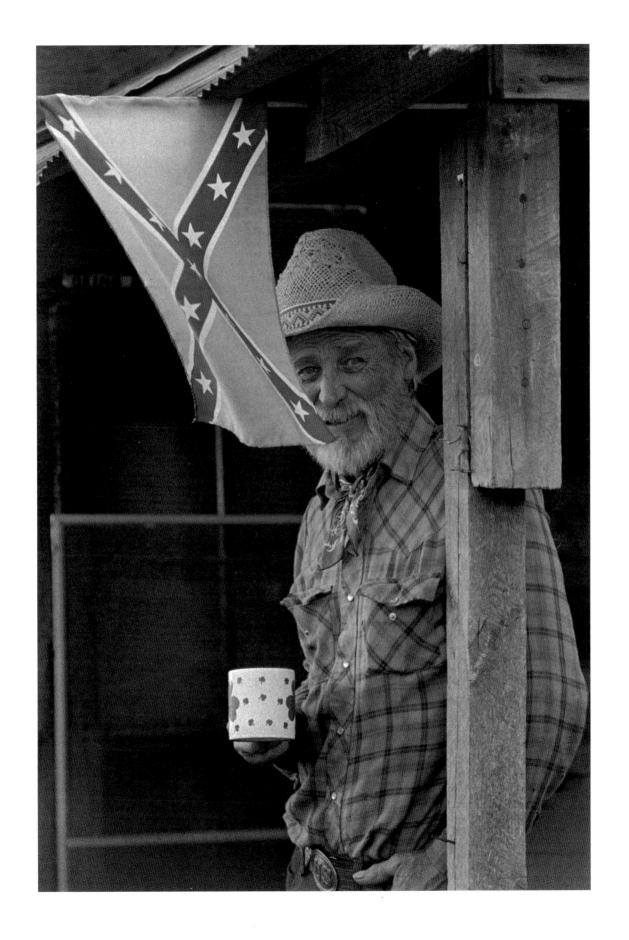

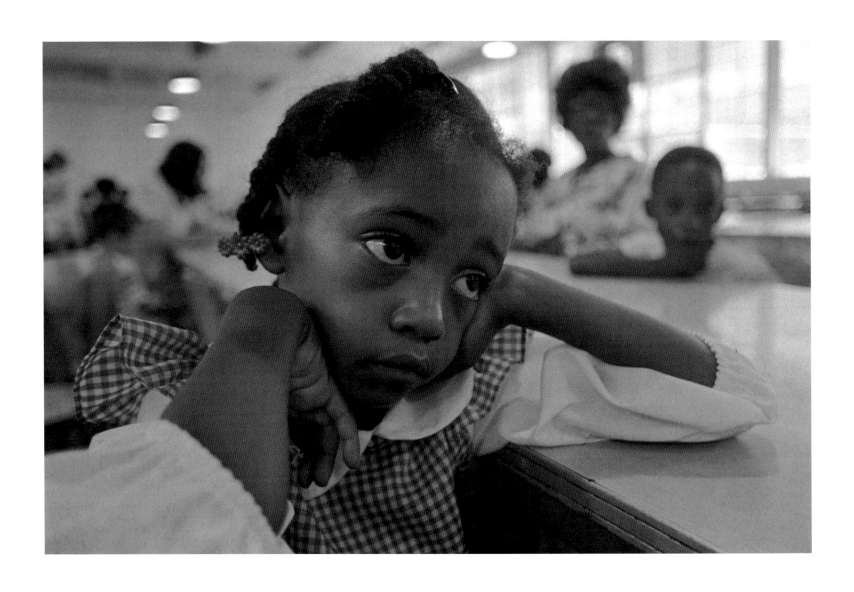

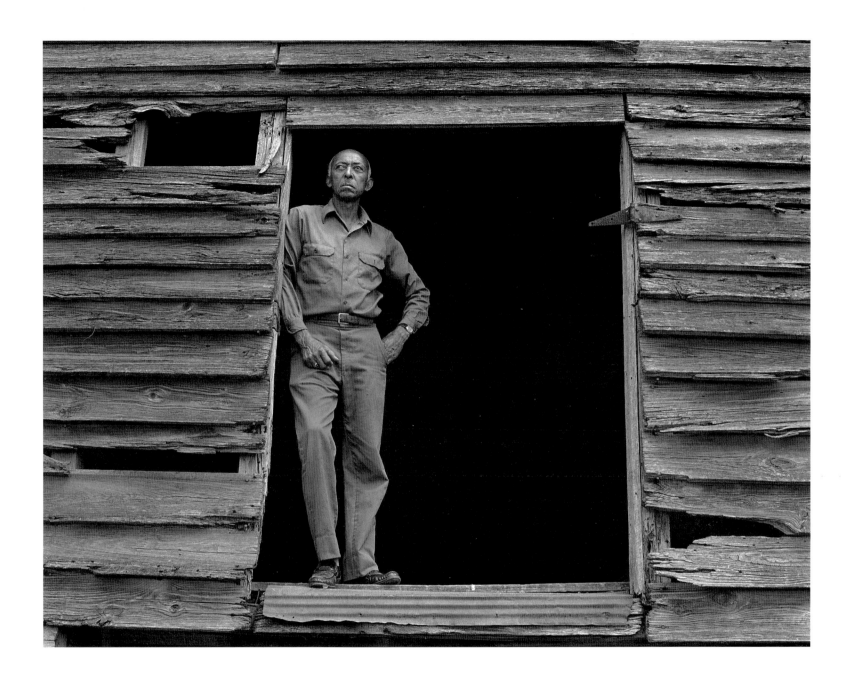

AFTERWORD

Ken Elkins: A Career in Pictures

BASIL PENNY

ONE COULD NEVER SAY that Ken Elkins has been a one-dimensional photographer.

He's shot all the presidents back to Eisenhower, Alabama governors during the past 40 years, Billy Graham and Walt Disney among the well-known.

"They're not as important as some of the others I shot, people like Ernest Mostella . . . Martha Smith . . . Pinky Burns . . . Willard Watson . . . James Lindsey . . . Mose Tolliver . . . Ab Jackson," says Elkins. "I'll stack any of these people up against the presidents. They're just salts of the earth, but great people."

Elkins retired as the *Anniston Star*'s chief photographer on his 65th birthday in 2000, after 42 years in the newspaper industry. His career began in 1958 at the *Huntsville Times*. He joined the *Anniston Star* in 1971.

"I knew I was talking to a pro, maybe even a genius, in the first interview, when I noticed him crooking his head from side to side," says Brandt Ayers, the *Star*'s publisher. "At first, I thought he had a tick. What he told me was he was looking at everything through a viewfinder.

"He was the photographer who was always on duty and alert to everything, and everything was of interest. But he's a lousy painter," Ayers says, laughing at his jab at Elkins' passion to produce on a canvas and board what he does so expertly with a camera.

Elkins met Martha Smith of Clay County at the Red Barn music hall, where she came dressed as Minnie Pearl. He remembers Willard Watson as a toy maker and master storyteller of Salisbury, North Carolina. He focused on Pinky Burns as an outdoorsman and folk icon in the Rabbittown community. Montgomery artist Mose Tolliver's work intrigued him. He did a photo feature on Lineville turtle hunter James Lindsey. Ab Jackson of Millerville has been in his viewfinder several times—picking peas on Jericho Road and once years ago when authorities busted up his moonshine still.

Ernest Mostella of Ashville may be his favorite, though. For 84 years, Mostella has made primitive fiddles, whose strings are cotton cord pulled tight by wooden winding keys. The instruments are a main revenue source for the St. Clair County man.

Elkins bought a fiddle when he did pictures for a story in the *Star* years ago. Every time he's in the vicinity, he checks on Mostella and buys another fiddle.

"I don't know what I'm going to do with all of 'em," he says. "I just try to help him out."

That's vintage Elkins, and a side some people might not know. He has a soft place in his heart as big as northeast Alabama for people down on their luck, and for stray animals.

He's left sacks of groceries on the porches of people in need. They probably never knew their benefactor's identity. That's the way he wants it.

More than a few times, he's carried food back to a stray dog or cat abandoned along a road. When he eats chicken on the run, he saves the bones in his van for the next stray.

"Ken is a master journalist with a camera, reporting on the people of the countryside as great photographers always have—

with images that rise to the level of art," says Chris Waddle, the *Star*'s vice president for news. "He and his work are alike—humane in a quietly heroic way."

How did this Marshall County native wind up with a camera in his hands? Pure chance, or boredom with Army life in Germany? Most likely it was a mix of the two.

Elkins dropped out of high school at Arab his senior year to help his dad farm. When the crop was in, he signed on with the Army and eventually landed in Germany.

With nothing to do, he wound up at the post exchange one day, where he bought his first camera, a Brownie Hawkeye. A simple box camera with fixed lens, he began shooting landscapes and buddies around the military base.

One of those buddies let him use his 35-mm camera with motor drive. That souped-up picture-taker whetted his appetite.

In 1958 and out of the Army, he shot a few pictures and worked for a short time in circulation at the *Huntsville Times* and dabbled in studio photography. Late that year, he moved to a full-time photography job with the newspaper.

What sealed photography as his profession was a picture made by Ernest McMeans of the *Times* staff, he says. It was of a man going to see his girlfriend after a big snow at Huntsville. Probably drunk, the man fell and froze to death.

"It was all there in the snow, where he had staggered to the left and then to the right to the spot where he fell. It was probably the most appealing picture I'd ever seen.

"*Life* magazine picked it up and ran it big on the last page of the magazine," said Elkins. "That's where they ran the best stuff.

"I looked at that picture and studied it. Every time I picked that magazine up, I'd turn to that picture. Seeing it kind of set me on fire.

"I thought, I could have done that." He was hooked, just like the bass fish he is so fond of catching.

Like others who look at his award-winning work, he's hard pressed to pick the best. But he has some favorites:

• A small child peeping around his mother's apron, probably the first time the youth had been photographed. The shot was made during a Huntsville assignment to find poverty in Rocket City. "Kids. They're so natural, so candid, you can hardly miss getting a good picture when you shoot a kid."

• A Cleburne County baptizing in the Tallapooosa River. "I waded out in the water to get pictures, and shot pictures on the bank. It really was a photographer's paradise."

• A gas station explosion in Gadsden. "I didn't get there 'til the fire was out. They were cleaning up. It was probably the best spot news I ever shot in my life . . . a fireman kneeling with hose hooked between his arms, and the water still running." The blast and the fire killed several people, including firefighters.

• Horses in a car. "I was sitting on Noble Street one day when I saw this car coming with two horse heads out a window. The guy was going to a sale with two Shetland ponies. He took out the back seat and got 'em in there somehow. I just started snapping pictures. I didn't have time to check my exposures." He got a prize-winning picture.

• Kids roller-skating on Gurnee Avenue. "I noticed one kid whose skates were too small, and he had cut the toes out. I started shooting him as he came toward me. The last shot was his toes sticking out and another skater framed by his legs. That was the picture I wanted."

Conversely, there are at least two pictures—both of flat tires—he wishes he'd shot:

• A hearse leading a procession to a cemetery had a flat, and the long line of vehicles was idled on the highway shoulder while the harried funeral director changed the tire. All were gone by the time Elkins could get there.

• Someone called Elkins about a wheelbarrow with a flat tire in downtown Anniston one day. Whoever was pushing the wheelbarrow had jacked it up, removed the tire and left to get it patched. Elkins had to finish processing the film he had in developer, and by the time he got there, the evidence was gone.

Nevertheless, by his reckoning he's won several hundred awards from the Associated Press, Alabama Press, and press photographers associations.

He has experienced change aplenty in the picture-taking

business. That Brownie Hawkeye gave way to a 4 x 5 speed graphic, which evolved to the 120-mm roll-film camera. Then the 35 mm became the press photographer's standard for many years.

Film became better and faster, but has taken a back seat to the newcomer on the block—the digital camera.

"I like it myself. It's so fast. Two minutes after getting back from an assignment, I can have it in the system—in full color.

"I miss not being able to hold my negatives in my hand, though," said Elkins, who admits that old habits indeed are hard to shake.

Reporters who've worked assignments with Elkins learn quickly that he has a remarkable way with people. Soft-spoken, he knows exactly how to talk to them, how to appeal to their sense of cooperation.

Driving along a road—he's been over most of them in all the surrounding counties—his memory is keen of people, places, and things framed by his viewfinder, pointing out the sites as he drives along. He can remember most of the details.

His "natural eye" for photographs awes many familiar with his talent. He sees pictures others pass by. Often he will stop in the middle of the road, turn around and retrace his path to get a picture he's seen.

"I can't think of anything else that I would have been happier doing," he said. "It's been a challenge. It's been good to me. Exciting."

Meanwhile, he continues to take pictures and travels with a camera everywhere he goes. And since retirement, he's found time to help his wife, Marcie, around the house and more time for his children—Karen Roberts, Keith, Ansel and Hilary Elkins—and two grandchildren. And to bass fish.

He and Karen compete in bass tournaments all over the southeast. He frees all he catches. "I never keep a bass. I think they're there to catch and enjoy. The challenge is catching and weighing in at a tournament, and then turn 'em loose for someone else to catch and enjoy.

"I just can't stand to kill a bass. I feel awful if I hook one deep and then it dies," he says.

CAPTIONS

1. Front porch, Talladega County, 1972

2. Bob Stoop, Jacksonville, 1977

3. Lettie Lett, Clay County, 1989

4. Calhoun County, 1974

5. Chicken truck wreck, Quintard Avenue, Anniston, 1984

6. Gulf Shores, 1990

7. Ches McCartney, the Goat Man, 1984

8. Jennie Lee Morrison, Centre, 1972–73

9. Berma Edmonds, Glenn Summerford Church, Scottsboro, 1984

10. Eva and John Rollins, Hollis Crossroads, 1980

11. Crystal Gayle Vaughn, Cleburne County, 1981

12. Wash and Hattie Stevens, Randolph County, 1984

13. Mary V. Adair, near Millerville, Clay County

14. Jody Watts, Clay County, 1989

15. Crops planted, Cherokee County

16. James Lindsey of Clay County at Meadow Lake Farm, Calhoun County, 1990s

17. Beulah Moses, 1989

18. Blacksmith working on a fence, Alexandria, 1989

19. Roy Parker holding two pictures of his wife, Clay County, 1988

20. Eppie Moore in her living room, Talladega, 1972

21. Chambers County, 1987

22. Calhoun County gas station, 1987

23. Anniston Train Station, 4th Street, 1980s

24. Ernest Marsteller, Ashville, 1989

25. County agent Sutt Matthews, Calhoun County, 1980s

26. Ansel Elkins, Calhoun County, 1968

27. Nelner Jean Welch, Clay County

28. Shelling beans, north of Jacksonville, 1979

29. Anniston, 1993

30. Calhoun County, 1981

31. Singing Sam, Madison County, 1968

32. Weekly Reader, Eulaton Elementary School, 1976

33. Huntsville, 1960s

34. Herb hunter Max Hyde, Ohatchee, 1979

35. Centennial celebration, Jacksonville, 1976

36. Near Able Mall, Cleburne County, 1980

37. Henry and Eva Luker, Clay County, 1989

38. Ohatchee, 1976

39. Madison County, 1964

40. "No Boys," Anniston, late 1970s

41. Craigford, 1978

42. Hurst Matthews, Gallant, 1987

43. Warren Musgrove, Horse Pens 40, 1980

44. Ed Hull, kneeling, and Daniel Paris, Randolph County, 1985

45. Berma Tyson, 1990

46. John Colvin, Etowah County, 1982

47. Jeff Thomas with his bike, Huntsville, 1960s

48. Nancy Hardy, Clay County, 1989

49. Shoe shop, Talladega, 1990

50. Shine Morris, Craigford, 1989

51. Cleburne County, 1984

52. Glenaddie Court, Calhoun County, 1972

53. Health care clinic, Hooks Bluff, 1978

54. Huntsville, 1960s

55. Talladega, 1982

56. Clay County, 1976

57. Russell Erskin Hotel, Huntsville, 1962

58. Arthur Dial, Talladega County, 1972

59. Ponies going to market, Quintard Avenue, Anniston, 1975

60. Brush Arbor Revival, Randolph County, 1976

61. Onie Waldrop, Randolph County, 1992

62. Talladega County, near Munford, 1982

63. Madison County, early 1960s

64. "In the Groove," Anniston, April 1971

65. Ku Klux Klan Rally, Talladega, May 1980

66. Emmet Waldrop, Randolph County 1990s

67. Georgia–Alabama State Line, 1990s

68. Huntsville, 1965

69. Tagged at first, Bynum Elementary, Anniston, 1976

70. Venus Deason, Choccolocco Valley, 1973

71. White Plains Bridge, Choccolocco Creek, 1972–73

72. Checkers, Ohatchee, 1990

73. Greene County, 1985

74. Jim Long, Millerville, 1981

75. Talladega County, 1970s

76. Clay County, 1988

77. Clean-Up Day, Anniston, 1982

78. Near Peaks Hill, Calhoun County, 1976

79. Baptism in the Tallapoosa River, 1986

80. Ku Klux Klan rally, Talladega, 1982

81. Brahm Springs Park, Huntsville, 1966

82. Meadow Lakes Farm, Oxford, 1990

83. Icy and Earl Griffin, Clay County, 1989

84. Floodwaters from Choccolocco Creek, Meadow Lake Farms, 1970s

85. Bill Morrison, Clay County, 1988

86. White Plains, 1976

87. Heflin, 1976

88. Huntsville, 1968

89. Cleburne County, 1980s

90. Fishing for coins, Huntsville, 1963

91. John Averson, Ragland, 1982

92. Ragland, 1980s

93. Snake handler, Jackson County, 1993

94. Henry Caldwell, Jacksonville, 1973

95. Zinn Park, Anniston, 1989

96. Randolph County, 1992

97. Ben O'Hara, Clay County, 1990s

98. April Ann Marchman, first day of school at 11th Street Elementary, Anniston, 1973

99. Monroe Wood, Clay County, 1998